THE BIG
ACTIVITY BOOK
FOR DIVORCED
PEOPLE

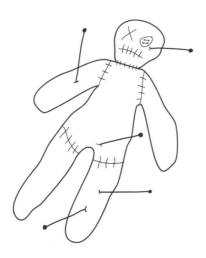

THE BIG ACTIVITY BOOK FOR DIVORCED PEOPLE

JORDAN REID AND **ERIN WILLIAMS**

A TarcherPerigee Book

tarcherperigee

an imprint of Penguin Random House LLC
penguinrandomhouse.com

Most TarcherPerigee books are available at special quantity discounts for bulk
purchase for sales promotions, premiums, fund-raising, and educational needs.
Special books or book excerpts also can be created to fit specific needs.
For details, write: SpecialMarkets@penguinrandomhouse.com.

Library of Congress Cataloging-in-Publication Data

Names: Reid, Jordan, author. | Williams, Erin, author.
Title: The big activity book for divorced people / by Jordan Reid and Erin Williams.
Description: New York: TarcherPerigee, 2021.
Identifiers: LCCN 2020044093 | ISBN 9780593192412 (paperback)
Subjects: LCSH: Divorce—Psychological aspects. | Divorce—Humor. | Divorced people.
Classification: LCC HQ814 .R46 2021 | DDC 306.89—dc23
LC record available at https://lccn.loc.gov/2020044093
p. cm.

Printed in the United States of America
1st Printing

Book design by Erin Williams

For the Divine Ms. March

DEAR DIVORCED PERSON,

Divorce! Hi-LARIOUS! Who doesn't find sidesplitting humor in things like alimony, division of mutually acquired property, and the destruction of the belief that one will, in fact, live happily ever after?

Divorce is the worst. We know this.

But you know what divorce also is? Really fucking common. And we have a secret to tell you: It's not the End Of Times that it may, at first, appear to be. Here's the thing: At its core, marriage is a social construct. Men came up with it (surprise!) to ensure that they produced biological heirs, and to lock down their property (the woman, naturally). When marriage was invented, people also did not typically live past age thirty, which makes "lifelong partnership" seem infinitely more doable.

Look, sometimes this wildly-antiquated-yet-universally-celebrated construct works out. And in some places, the whole "man" and "woman" thing has even been relaxed to include non-hetero partnerships! Which is great! But sometimes what happens is that two individuals who decided to bind their lives together for all eternity realize that over the course of a decade or three what they want out of their time on this planet went ahead and changed.

And change can be pretty great, too—see: evolution.

Whether your divorce is mutual and amicable (in which case, congratulations; you are a unicorn) or full-on Henry VIII (in which case . . . oh dear), we're here to tell you that you are not alone. You will come out on the other side, and life will be beautiful in ways you cannot even imagine.

So find a pencil, hunt around for that sense of humor (you've still got it . . . right? Right!), and remember: laughing is the best cure around. It's also way cheaper than therapy. If you're having a rough day, head to page 76 for some new interior decor ideas to try, including "The Opposite of What Your Ex Would Want in Literally Every Way." If you're having a really rough day, flip over to page 65 and color in the soothing Jennifer Garner, who is totally living her best life (as you will be, too).

Because you're still you. The same "you" that you were before you ever got married. Remember that person? They were fun! And nobody ever got mad at them for eating crackers in bed.

Love,
Jordan & Erin

P.S. Therapy is probably a good idea, too. Just saying.

HOW TO USE THIS BOOK

1. Pick it up whenever the mood hits: In the morning, instead of checking your ex's social accounts the second you open your eyes (this is never, ever a positive life choice); in the afternoon, instead of a four-hour phone call with your attorney that's basically just a very, very expensive therapy session (again: activity book = much cheaper); in the evening, instead of eating an entire pie (although eating an entire pie while paging through this book sounds like the makings of a pretty amazing night).

2. While it is loosely divided into sections, it does not possess anything resembling a coherent storyline. Flip forward, flip back, pick a page at random and start there. Divorce isn't exactly a chilled-out cakewalk, so consider this book the opposite of everything else you're dealing with: Do it, don't do it, do it badly, regift it, rip it up (therapy!). With this book, you get to do whatever you want, and nobody gets to judge you. Doesn't that feel spectacular?

3. If you're so inclined, take a picture of your creations and tag us on Instagram @ramshackleglam and @erin_r_williams. Divorce can feel massively isolating, but speaking from experience, there are a lot of divorced people out there, and we are stronger together.

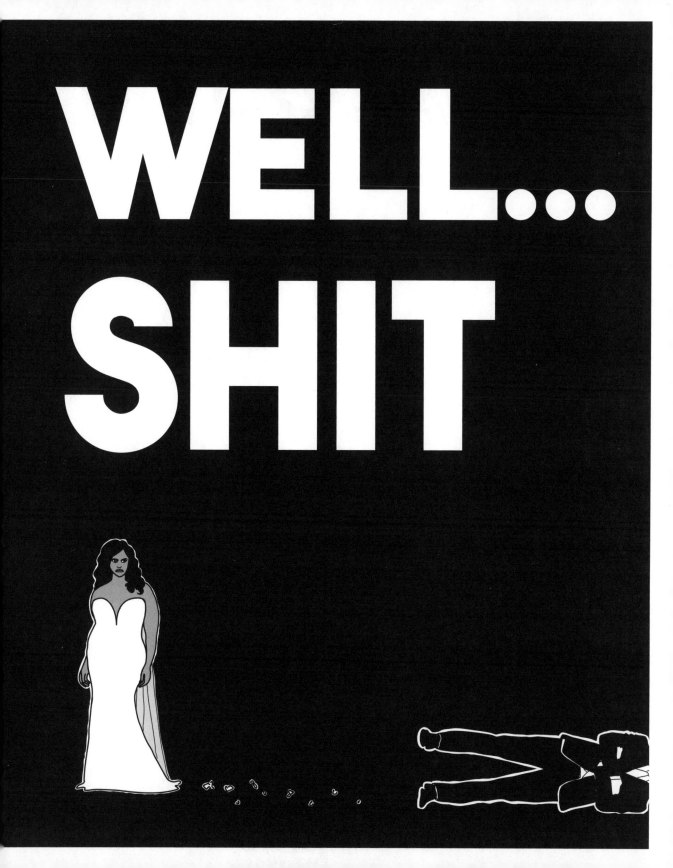

ALL ABOUT ME

Draw your awesome, independent self:

BYE to whoever was over here

TELL ME MORE

My marital status is:
- ☐ Divorced, duh, why else would I have this book?
- ☐ Consciously uncoupled. Namaste.
- ☐ Single and ready to mingle, y'all.
- ☐ Technically married, but evaluating my options.

My current state of mind is (check all that apply):
- ☐ Excited
- ☐ Terrified
- ☐ Overwhelmed
- ☐ Despondent
- ☐ Like I want to cry in a happy way
- ☐ Like I want to cry in a not-happy way
- ☐ Like I need a Twinkie
- ☐ Like I need a nap
- ☐ Like I need a cocktail
- ☐ All of the above

Here is what I'm going to manifest right on into my life in the coming weeks/months/years (check all that apply):
- ☐ More money
- ☐ More sex
- ☐ More time
- ☐ More space
- ☐ More energy
- ☐ More self-care
- ☐ Less of this person: _____
- ☐ More of this person: _____
- ☐ Less of this thing: _____
- ☐ More of this thing: _____
- ☐ Pure, unadulterated joy

I am currently enjoying (check all that apply):

☐ Satisfaction in the knowledge that I was, of course, right (about everything)

☐ Vengeance

☐ Schadenfreude

☐ *Eat, Pray, Love*

☐ Total and complete silence

☐ Edibles

In my dream future, I am:

☐ The host of a badass podcast

☐ One of those weirdos who eats flaxseed and gets up early to exercise

☐ Living in sin with (circle all that apply) one or more of the Hemsworth brothers, Beyonce, Idris Elba, Gal Gadot, and/or this person: _____

☐ Living in a gated community inhabited solely by fluffy kitty cats and interacting only with the person who delivers me a constantly rotating selection of delicious cheeses

TURN DIVORCE INTO AN ACROSTIC

Use each letter to start a word or phrase, and then combine them into a glorious, glorious poem.

D _____

I _____

V _____

O _____

R _____

C _____

E _____

Harry Styles via fan mail

the sandwich you were crying into

a ghost

your real estate agent

Carol from HR

TOP FIVE

WHO DID YOU TELL ABOUT YOUR DIVORCE FIRST?

1. _____

2. _____

3. _____

4. _____

5. _____

Journal

Everyone else in my life found out because:
 a) I told them (very loudly, with many associated wails)
 b) They guessed (because of course)
 c) I hooked up with a twenty-two-year-old in front of them
 d) I posted a rant that may or may not be currently resulting in a defamation lawsuit, woops
 e) This happened: _____

I wish I had announced my divorce by:
 a) Starting a GoFundMe
 b) Sending everyone I know a selfie of me holding this book
 c) Changing my relationship status on Facebook and seeing who noticed
 d) Changing my identity and disappearing to a Virgin Island, never to be seen again

MOVIES THAT WILL HELP

When you're going through a divorce, some movies must be avoided at all costs (see: The Notebook, Ghost, The Bodyguard—#justno), *but others demand to be streamed immediately—maybe even on the night those papers are signed.*

Sex and the City, because at least your wedding didn't involve any wearable birds.

The First Wives Club, because we should all sing, dance, and champagne ourselves into the next stage of life.

Waiting to Exhale, because every single woman in this movie is far, far better off after ditching their problematic relationship.

Under the Tuscan Sun, because Diane Lane got it right, what with the Italian lover and Italian food and adorable Italian Vespa rides through adorable Italian streets.

Get Him to the Greek, because it's hilarious.

Marriage Story, because hahahaha just kidding, *Marriage Story* makes everything worse.

COLOR IN THE FOUR SCREAMING ADAM DRIVERS

this movie will not help

WORD ASSOCIATION TIME!

Write down the first word that comes to mind when you read each of the below.

Cohabitation: _____

Conscious uncoupling: _____

Valentine's Day: _____

Lawyer: _____

In-laws: _____

Prince Charles: _____

The Bachelorette: _____

Money: _____

Dating: _____

Monogamy: _____

Chocolate: _____

Naps: _____

Elizabeth Taylor: _____

Social media: _____

Switzerland: _____

Cheetos: _____

Self-care: _____

Xanax: _____

Cat ladies: _____

NPR: _____

PBS: _____

HGTV: _____

QVC: _____

Wellness influencers: _____

Say Yes to the Dress: _____

APPRECIATE OUR HERO

Remember when Britney went ahead and zoomed right off the deep end? Maybe you're feeling a little Britney-circa-2007 these days, so go ahead: Show her a little love. Just maybe don't shave your head. Or, what the hell, do.

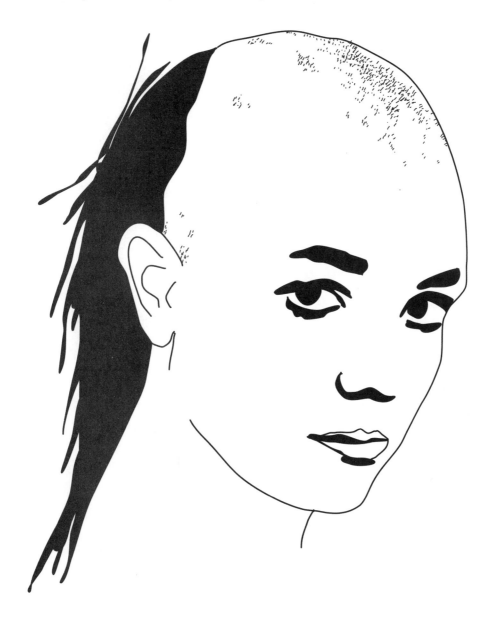

MATCH THE SONG YOU CAN NEVER, EVER LISTEN TO AGAIN TO ITS SINGER

. . . Unless your goal is to lose half your body weight in tears.

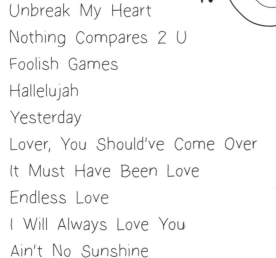

Unbreak My Heart
Nothing Compares 2 U
Foolish Games
Hallelujah
Yesterday
Lover, You Should've Come Over
It Must Have Been Love
Endless Love
I Will Always Love You
Ain't No Sunshine

Bill Withers
Diana Ross & Lionel Richie
Sinéad O'Connor
Toni Braxton
Whitney Houston
Jewel
Leonard Cohen
The Beatles
Jeff Buckley
Roxette

Also anything ever written by Adele.

These songs are also banned:

Nope.

ANSWERS:
Toni Braxton, Unbreak My Heart; Sinéad O'Connor, Nothing Compares 2 U; Jewel, Foolish Games; Leonard Cohen, Hallelujah; The Beatles, Yesterday; Jeff Buckley, Lover, You Should've Come Over; Roxette, It Must Have Been Love; Diana Ross & Lionel Richie, Endless Love; Whitney Houston, I Will Always Love You; Bill Withers, Ain't No Sunshine

OBSCURE MARRIAGE AND DIVORCE LAWS
THAT ARE SOMEHOW STILL ON THE BOOKS

Impress your friends at the couples-only dinner party they were hesitant to invite you to!

In Kentucky, a certain level of indecision is acceptable, but only up to a point. You can marry the same person three times, but the fourth? Oh no, that would be illegal.

Until 2015, same-sex divorce was not legal in Texas. This, of course, is because same-sex marriage was not, until that point, technically legal in Texas, and to grant a divorce would amount to the state admitting that the marriage was valid.

You cannot marry someone on a dare in Delaware.

In Salem, Massachusetts, married couples may not sleep nude in rented rooms (or the witches will get you).

In Utah, first cousins are only allowed to marry if they are over the age of 65. Spicy!

Anyone who lives in Wichita, Kansas, can divorce their spouse for mistreatment of their mother. As mothers ourselves, we approve this message.

In Tennessee, you can divorce your spouse if they try to kill you—but only in a "malicious manner," which is, of course, distinct from the many other ways that your spouse can try to kill you.

If a couple wants to divorce in New York but cannot agree on anything, they must first figure out a way to agree on at least one thing: Filing on the grounds of irreconcilable differences.

In the Cape Cod town of Truro, a man who wishes to wed must first hunt and kill either six blackbirds or three crows. Bird-slaying = masculinity, apparently.

In Mississippi, the county clerk is legally allowed to withhold a marriage license if they believe that either party is drunk or insane.

MATCH THE CELEBRITY COUPLE TO THEIR MARRIAGE SPAN

Well, hooray for the sounds of FUCKING silence!

*we DARE you to cut out this Nicolas Cage face, place it atop your pillow, and just TRY to sleep at night. Go on.

Pop Quiz: *Seventy-three hours after your wedding, were you still married? Um, yes?:___ Um, no:___*

If you answered "Yes," congratulations: If pitted against Kim Kardashian and Kris Humphries, you win the "marital superstar" award.

Match the celebrity couples to the life span of their respective unions.

Luann de Lesseps and Tom D'Agostino	1 year
Britney Spears and Jason Alexander	7 months
Carmen Electra and Dennis Rodman	55 hours
Jennifer Lopez and Cris Judd	107 days
Eddie Murphy and Tracey Edmonds	5 months
Mario Lopez and Ali Landry	9 days
Renée Zellweger and Kenny Chesney	14 months
Drew Barrymore and Tom Green	4 months
Nicolas Cage and Lisa Marie Presley	2 weeks
Aaliyah and R. Kelly	15 days
Katy Perry and Russell Brand	6 months
Janet Jackson and James DeBarge	9 months

WE HAVE ALL THE ANSWERS: Luann de Lesseps and Tom D'Agostino - 55 hours; Britney Spears and Jason Alexander - 7 months; Carmen Electra and Dennis Rodman - 9 days; Jennifer Lopez and Cris Judd - 9 months; Eddie Murphy and Tracey Edmonds - 2 weeks; Mario Lopez and Ali Landry - 15 days; Renée Zellweger and Kenny Chesney - 4 months; Drew Barrymore and Tom Green - 6 months; Nicolas Cage and Lisa Marie Presley - 107 days; Aaliyah and R. Kelly - 5 months; Katy Perry and Russell Brand - 14 months; Janet Jackson and James DeBarge - 1 year.

PLACE THE SITUATION ON THE PAIN SCALE

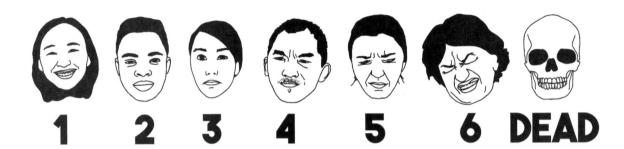

1	2	3	4	5	6	DEAD

_____ Netflix not working

_____ Ex changed Netflix password

_____ Ex posted new Instagram pic

_____ Ex is dating

_____ You are dating

_____ Hearing the words "Are you dating?"

_____ Downloading dating apps

_____ Going to a bar

_____ Dinner with married friends

_____ Dinner with single friends

_____ Dinner with anyone but your dog

_____ Talking about divorce with your parents

_____ Talking about divorce with your friends

_____ Talking about divorce with Carol from HR

_____ Watching *Kramer vs. Kramer*

_____ Pilates

GET THROUGH YOUR INSTAGRAM FEED WITHOUT CRYING

AVOID ENGAGEMENT PICS FEATURING STUNNING TWENTY-FIVE-YEAR-OLDS! HAPPY FAMILIES IN MATCHING HOLIDAY ONESIES! AUNT CORDELIA'S PASSIVE-AGGRESSIVE POSTS ABOUT THE MEANING OF COMMITMENT!

START

FINISH

DIVORCE STATS TO MAKE YOU FEEL BETTER WHEN YOU'RE LYING AWAKE AT NIGHT

In the United States, a divorce is finalized every 36 seconds. Go sing Ariana Grande's "Thank U, Next." Boom: 5.75 divorces just happened.

Three quarters of divorced people eventually remarry. Which, you know, is great, assuming their next marriage isn't like the last one. Don't think about that.

The state with the lowest divorce rate is Iowa. If you want a lower chance of getting divorced again and you're not blessed enough to already be an OG Hawkeye, start packing.

The average age for divorce in the U.S. is thirty. If you're younger than thirty, congrats: you're an early adopter. If you're older than thirty, congrats: you get to claim Ultimate Survivor Status.

The Real Housewives franchise has an overall divorce rate of 35 percent. If you aspire to be just like the inimitable Countess Luann, you're in excellent company.

DRAW THE HAIRCUT YOU'RE GOING TO GET **LATER**

Have you ever had bangs? Then you know that they are virtually always a mistake. We know: You want them anyway. Just give it a few weeks, okay?

DIVORCE CALLIGRAPHY

Practice iconic hand-lettering here before taking a stab at a homemade greeting card for your ex.

a b c d e

f g h i j k

l m n o p

q r s t u

v w x y z

Keep practicing below!

KEEP IT CLASSY

You've probably seen a ton of hilarious divorce memes on Facebook, if by "hilarious" you mean "What your grandma would put on a Someecard if she knew what Someecards were." Give these gems the ironic treatment by rewriting them with your fancy new calligraphy.

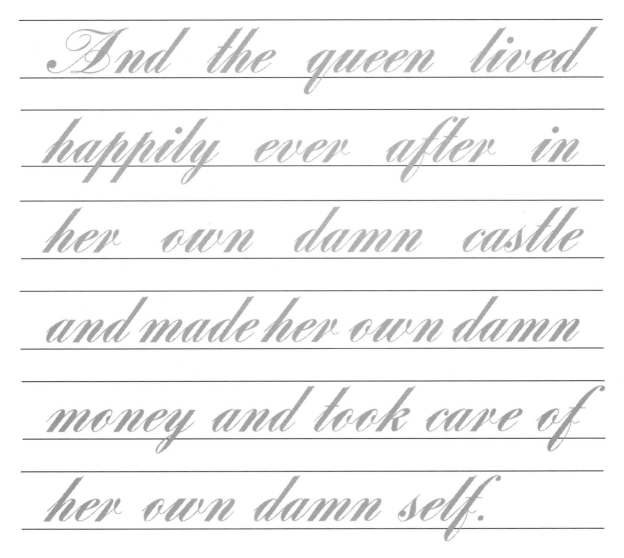

And the queen lived happily ever after in her own damn castle and made her own damn money and took care of her own damn self.

I still miss my ex but my aim is improving.

Jolene, I'm begging you: Please just take him, just because you can.

JoLEEEENE

COLOR AND THEN BEHEAD KING HENRY VIII!

Henry VIII was a real shit: He literally legalized divorce in the Church of England for the sole purpose of bailing on his first wife for a woman he deemed hotter and younger—and then, when the second one didn't work out, either, he skipped the legal process and chopped her head off instead. It wasn't the last time!

No matter how bad your ex was, chances are they did not behead you, because beheaded people usually aren't capable of filling in activity books. Consider yourself . . . lucky? Sorta?

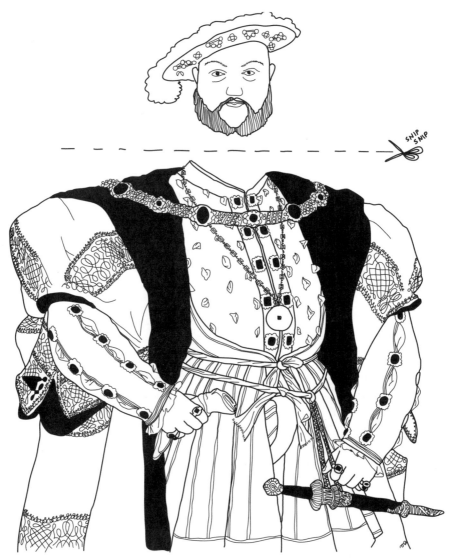

SNIP SNIP

CREATE YOUR OWN DIVORCE PLAYLIST

As a bonus, these are all great workout songs. Revenge body, ahoy.

Cry Me a River	Justin Timberlake
You Oughta Know	Alanis Morissette
Before He Cheats	Carrie Underwood
Don't Speak	No Doubt
Stronger (What Doesn't Kill You)	Kelly Clarkson
Stronger	Britney Spears
You Don't Own Me	Lesley Gore
Survivor	Destiny's Child
Tainted Love	Soft Cell
Go Your Own Way	Fleetwood Mac
Since U Been Gone	Kelly Clarkson
Fuck You	CeeLo Green
No Scrubs	TLC
Somebody That I Used to Know	Gotye ft. Kimbra

And these must-haves: _____

THINGS DIVORCED PEOPLE SHOULD AVOID

the dentist, because things are bad enough

mothers-in-law

permanent body modifications

Justin and Hailey Bieber

Sleeping With the Enemy

100% TRUE* REASONS PEOPLE HAVE GOTTEN DIVORCED

Did you get divorced because of an affair? Money troubles? Disagreements over how to raise your kids? Minor leagues, darling. We'll see you a few arguments over bills and raise you a demonic possession.

Former White House communications director Anthony Scaramucci's wife divorced him when he accepted an offer to work for Donald Trump. Similarly, seventy-three-year-old Californian Gayle McCormick left her husband of twenty-two years after she found out he planned to vote for #45.

A Cambodian couple getting a divorce in 2008 could not agree on division of assets, so they sawed their house in half. Thrifty!

An Italian man filed for divorce from his wife because he believed her to be possessed. Seems she had been doing things like . . . you know . . . levitating. NBD.

A twenty-nine-year-old Japanese woman divorced her husband because he didn't care for *Frozen*. The woman felt that indifference toward Elsa and crew suggests that "there's something wrong with you as a human being."

Judge Judy divorced her first husband because, in her words "he always viewed my job as a hobby and there came a time where I resented that." Bam.

Marvin Gaye allegedly intended for his album *Here, My Dear* to bomb, because a judge had ordered half of the album's profits to go to his ex-wife.

A UK woman filed for divorce because her husband wanted her to dress up as a Klingon, and speak to him in Klingon. Just going to speculate that this wasn't the *only* reason she felt compelled to end the marriage.

A ninety-nine-year-old Italian man filed for divorce after he discovered letters that his ninety-six-year-old wife had written to her lover—in the 1940s. These people also hold the record for the world's oldest couple to divorce.

A thirty-four-year-old man filed for divorce from his new twenty-eight-year-old bride because her makeup washed off during a dip in the ocean and he felt that she had "deceived" him using makeup and false eyelashes. This man is a fucking asshole.

*According to the internet, so ¯_(ツ)_/¯

"HELPFUL" ADVICE YOU GET FROM STRANGERS

Mention you're getting/have gotten divorced, and all of a sudden everyone from your boss's wife's second cousin Clyde to the girl behind the counter at the weed store has all the wisdom in the world to impart. Check off the expertise with which you've been gifted.

☐ Have you tried a therapist?

☐ Have you tried a couples counselor?

☐ Have you tried date nights?

☐ Have you tried an open marriage?

☐ Have you tried doing ayahuasca together?

☐ Oh, see, I was raised to believe that marriage is forever. But no judgment!

Sorry, Tori

☐ Wait, Tori Spelling totally wrote a blog post about this. Hold on, let me find it real quick . . .

☐ My Uncle Gerald got divorced. He died.

Journal

Also these gems: _____

TOP FIVE

SELF-CARE ACTIVITIES THAT ACTUALLY WORK

Alan Watts lectures
on YouTube (trust us)

1. _____

2. _____

3. _____

4. _____

5. _____

Washable Watercolors

watercolors

complicated skincare
routines

meditation

CHECK-IN:

Today is: ___/___/____ .

On a scale of 1–10, my anxiety level is _____ .

I'd feel better if I were (check all that apply):

☐ Watching *Love Is Blind*
☐ Talking to my attorney
☐ Exercising
☐ Hanging out with this person: _____
☐ Making out with this person: _____
☐ Alone literally anywhere
☐ Asleep

I'd feel worse if I were (circle all that apply):

☐ Watching *Love Is Blind*
☐ Talking to my attorney
☐ Exercising
☐ Reading the 4,000th article my parents have emailed me
☐ Filing my taxes
☐ Cleaning this thing that my ex LITERALLY NEVER CLEANED: _____
☐ Still married

The thing I'm most worried about is _____, but this probably won't happen because _____. But even if it did happen, everything would eventually be okay, because _____. Whew.

Here are five things I'm really looking forward to:

1. _____
2. _____
3. _____
4. _____
5. _____

I have twenty bazillion things on my plate, but fiiiiiine, I will do one or more of the following today:

☐ Sit in a silent, air-conditioned room with a cold Sprite
☐ Engage in at least twenty minutes of my favorite form of exercise, because endorphins
☐ Call (not text) someone who makes me happy
☐ Eat a meal that's delicious and good for me, because I deserve it
☐ Do one of those self-care "spa nights" that everyone says makes you feel better and actually kinda does

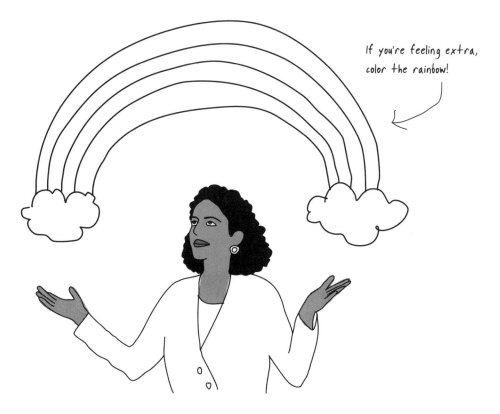

If you're feeling extra, color the rainbow!

COLOR IN THE BLUE TITS

Fun Fact: The Eurasian blue tit is one of several largely monogamous species that sometimes end up getting the animal version of divorced and ditching their long-term partner. You and the tits are two of a kind.

YOU'VE CHANGED

HOW MANY WORDS CAN YOU MAKE OUT OF THE LETTERS IN

IRRECONCILABLE DIFFERENCES?

Edible

Fibs

Silence

THE DIVORCE DIET

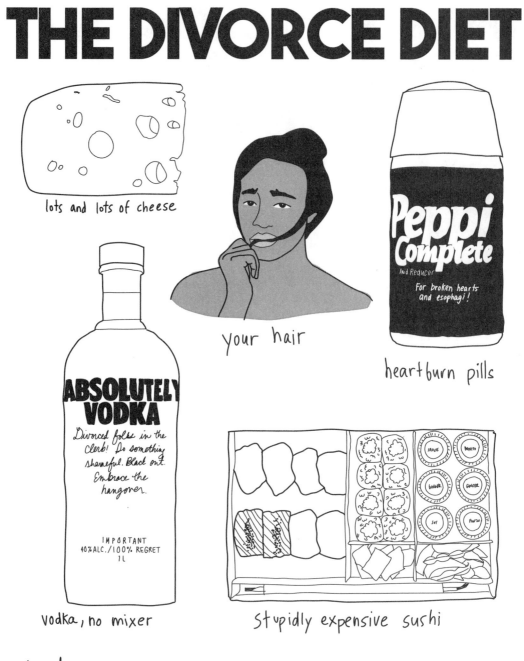

lots and lots of cheese

your hair

Peppi Complete
Acid Reducer
For broken hearts and esophagi!

heartburn pills

ABSOLUTELY VODKA
Divorced folks in the clerb! Do something shameful. Black out. Embrace the hangover.

IMPORTANT
40% ALC./100% REGRET
1L

vodka, no mixer

stupidly expensive sushi

Journal

All I want to consume right now is _____. I am/am not going to indulge this desire. I feel _____ about that choice.

THE REVENGE PAGE

Remember how, in grade school, you used to draw illicit things in your class notebooks (boobs with enormous areolas, the word "SHITFUCKER," your teacher naked, etc.) and then frantically draw over them until they were hidden under a billion scribbles? No? Just us?

Well, you missed out. Give it a shot.

1. *Write down the name of the person who has been the absolute worst during your divorce process. This could be your ex, obvi, but get creative. Think: your lawyer, your ex's lawyer, your sister-in-law, your boss, the Starbucks barista who refuses to remember that, yes, you do need extra whipped cream, whatever.*
2. *Write "IS A JERKFACE"* next to that name. Decorate it. Go crazy. If you feel the need to draw a picture of that person with pimples and a bowl cut, definitely do that.*
3. *Draw circles around and over your creation until it is obscured, so that no one who walks by and casually glances down will see anything more than a big black smear.*
4. *Feel superior with your secret knowledge that _____ is, in fact, a jerkface, and now it's official.*

** Feel free to improvise here.*

TURN THE SQUIGGLE INTO A COMFORTING THING

make this a happy baby

make this a pretty flower

make this your favorite grandparent

make this your childhood pet

FILL IN THE BLANK: YOUR THEME SONG

"Survivor" is, objectively, the best song ever. Yes, ever. Add the missing lyrics because you obviously know them by heart. If you don't, invent your own.

Now that you're outta my life, I'm so much _____ .

You thought that I'd be weak without ya, but I'm _____ .

You thought that I'd be broke without ya, but I'm _____ .

You thought that I'd be sad without ya, I laugh _____ .

Thought I wouldn't grow without ya, now I'm _____ .

Thought that I'd be helpless without ya, but I'm _____ .

You thought that I'd be stressed without ya, but I'm _____ .

You thought I wouldn't sell without ya, sold _____ .

LOOKING FOR THE
ANSWERS?
JUST GO LISTEN TO THE SONG, OKAY?

GET YOUR PAYCHECK TO YOUR WALLET WITHOUT LOSING IT ALL (JUST, UM, MOST OF IT)

AVOID CELEBRITY HAIR COLORISTS! UNCONSCIONABLY EXPENSIVE IMPULSE BUYS! FOUR-HOUR PHONE CALLS WITH YOUR LAWYER'S PARALEGAL'S SECRETARY'S ASSISTANT WHO INEXPLICABLY BILLS AT $150/HOUR!

START

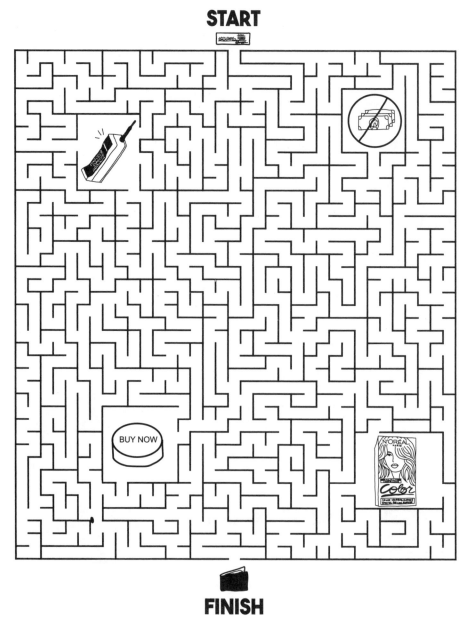

FINISH

MATCH THE CELEBRITY TO THE DIVORCE QUOTE

a) "I don't care what you think about me. I don't think about you at all."

1. Voltaire

b) "You know why divorces are so expensive? Because they're worth it."

2. Nora Ephron

c) "How many divorces are caused by the word *nothing*? I think this would be a very interesting statistic."

3. Oscar Wilde

d) "Divorce is the one human tragedy that reduces everything to cash."

4. Robert Anderson

e) "For a long time, the fact that I was divorced was the most important thing about me. And now it's not. Now the most important thing about me is that I'm old."

5. Sophie Kinsella

f) "Divorces are made in heaven."

6. Rita Mae Brown

g) "In every marriage more than a week old, there are grounds for divorce. The trick is to find, and continue to find, grounds for marriage."

7. Willie Nelson

h) "Divorce is probably of nearly the same date as marriage. I believe, however, that marriage is some weeks the more ancient."

8. Jennifer Weiner

i) "Nobody ever died of divorce."

9. Coco Chanel

DIVORCE MERCH YOU CAN ACTUALLY BUY

ANGRY CANDY HEARTS

This Valentine's Day, treat your ex to the timeless taste of flavored dust while reminding them that they can, in fact, GTFO.

A NEW T-SHIRT

Classy.

AN EX-SPOUSE VOODOO DOLL

If you have to stick pins in something, best not be a something that can file a lawsuit against you.

A CANDLE

Smells like rage and empty bank accounts.

A BLINKING SASH

Fierce. And helpful during a blackout!

THIS BOOK!

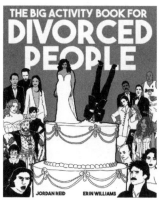

WORD LADDER: YOU RN

Make as many words as you can out of each word, changing only one of the letters each time. All words have to be real. We will enforce this Very Important Rule via the microchip embedded in this book's spine, just in case you were planning on suggesting that DAAD is a word. It is not, unless you are a small child whose parent won't let them watch another episode of Sofia the First.

Here, we did the first couple for you.

COLD	DEAD	HEART
BOLD		
HOLD		

COLOR IN THIS ATTORNEY'S OFFICE!

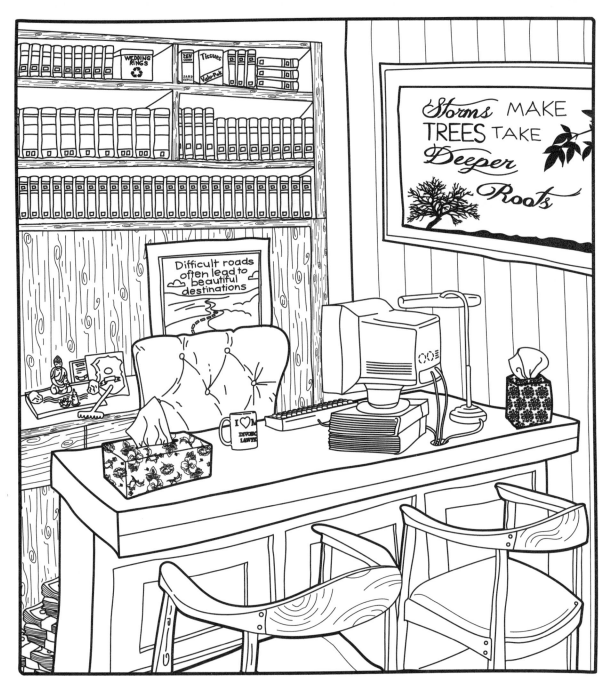

WORD SCRAMBLE:
TERRIFYING LEGAL TERMINOLOGY

There's no getting around it: Legal shit is scary. The good news: It's scary for everyone, and you'll be okay. Even if you do have to submit your alternate dispute resolution proposal before moving ex parte for a preliminary injunction and temporary restraining order and filing an action for partition of real property and jointly held assets. (Deep breaths.)

Tall Oracle _____

Scabrous Hepa _____

Proofed Fro Nub _____

Crude Junipers _____

Inject Boo _____

Creep Dent _____

Stoic Nan _____

Rott _____

Tsases _____

Croctnta _____

Jocobtine _____

WONDERING WHAT TO DO WITH YOUR OLD WEDDING ATTIRE?

Reclaim that space in your closet—and maybe get some new sheets to boot.

DIY CHUPPAH
To decorate your divorce party, of course

DRAMATIC BEDDING

Maybe Febreze that shit first

FISHING NET
(Bonus: Learn to fish with net)

AERIAL SILK GYM
Skip this if rhinestones were involved

KINDLING
So cozy

MATCH THE CELEBRITY TO THE COMPLETELY CONFUSING EX

Hey, we all have them. Match the celebrity to the other celebrity whom they inexplicably dated.

Pink	Barbara Streisand
Amy Poehler	Tila Tequila
Janet Jackson	Joey Fatone
Cher	Shia LaBeouf
Rihanna	Bob Sagat
Kim Kardashian	Dennis Rodman
Katie Couric	Nick Lachey
Elizabeth Taylor	Tom Cruise
Michael Jackson	John Stamos
Madonna	Matthew McConaughey
Ed Norton	Lisa Marie Presley
Billy Corgan	Colin Farrell
Andre Agassi	Courtney Love

ANSWERS:

Pink & Joey Fatone; Amy Poehler & John Stamos; Janet Jackson & Matthew McConaughey; Cher & Tom Cruise; Rihanna & Shia LaBeouf; Kim Kardashian & Nick Lachey; Katie Couric & Bob Saget; Elizabeth Taylor & Colin Farrell; Michael Jackson & Lisa Marie Presley; Madonna & Dennis Rodman; Ed Norton & Courtney Love; Billy Corgan & Tila Tequila; Andre Agassi & Barbra Streisand

46

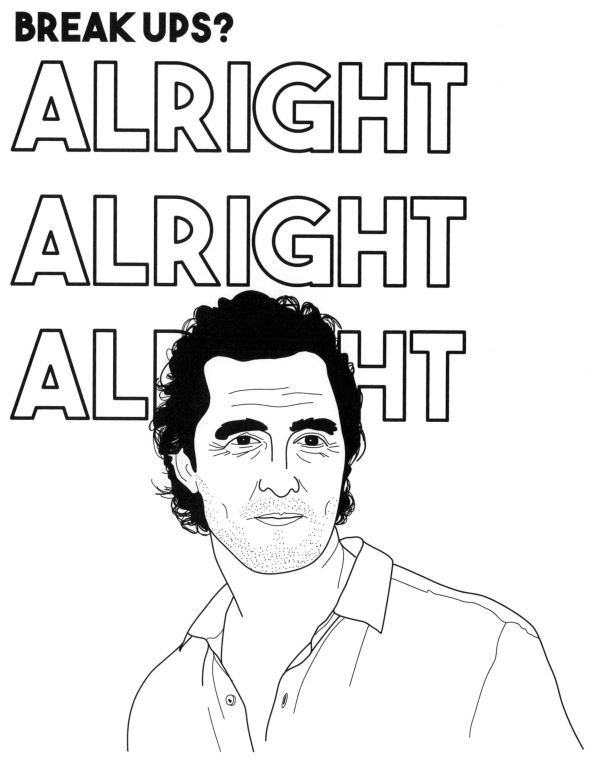

Brave

They say divorce is "a death by a thousand cuts"—and in many cases that's precisely what it can feel like. There are few things that bring out the worst in people like fear. And when what you're talking about is the dissolution of an imagined future, fear has a tendency to get in the driver's seat and tell you to sit down, shut up, and don't even think about opening up Google Maps and trying to navigate, because you are not the boss right now.

Which means that this time in your life should be one of forgiveness.

A few reminders, because they're important:

It is okay to wonder if you made a mistake.
It is okay to be terrified.
It is okay to fall apart.
It is okay to be numb.
It is okay to be exhausted.
It is okay to be excited.
It is okay to be happy.
It is okay to be exhilarated.
It is okay to be all of those things or none of them.

50

AND

Remember: The journey that you're on isn't about "making a new life" or "finding happiness again." It is both of those things to some extent, of course, but really: It's about figuring out how to love yourself. By yourself. It's also okay if you're not there yet, or if such a thing feels frankly impossible.

Another reminder, courtesy of Brené Brown:

> As you think about your own path to daring leadership, remember Joseph Campbell's wisdom: "The cave you fear to enter holds the treasure you seek." Own the fear, find the cave, and write a new ending for yourself. . . . Choose courage over comfort. Choose whole hearts over armor. And choose the great adventure of being brave and afraid. At the exact same time.

So sure, perhaps you feel sad. Angry. Confused. Uncertain that you'll be able to love yourself by yourself.

Brave and afraid, though?

That you can do.

It's a start.

(Also, you get the whole bed to yourself now! Woot.)

CHECK OFF THE THINGS YOU'LL DO NOW THAT YOU'RE DIVORCED

☐ Sleep horizontally

☐ Order a meal, and eat it all (no hovering forks)

☐ Buy one of those enormous pregnancy pillows that we all secretly want to sleep with anyway

☐ Get a puppy. Or five!

☐ Fart with reckless abandon

☐ Put your finger in your nostril and just leave it there

☐ Lean into your hobby of examining your pores

☐ Forget you own a razor

☐ Forget you own a gym membership

☐ Go on a trip to this place:_____

☐ Binge-watch this show:_____

- [] Get a haircut

- [] Get a piercing

- [] Get a tattoo

- [] Stare at your phone all goddamn day if you want to

- [] Plaster your social media feeds with pictures of you looking incredible

- [] Eat onions without offending anyone

- [] Look at your phone during dinner without offending anyone

- [] Play Fortnite for twelve straight hours without offending anyone

- [] Sleep on the couch without offending anyone

- [] Load the dishwasher without offending anyone

- [] Leave the toilet seat up. Or down! Or throw it out the fucking window! The FREEDOM!

YOU CAN ALSO DO THESE THINGS:

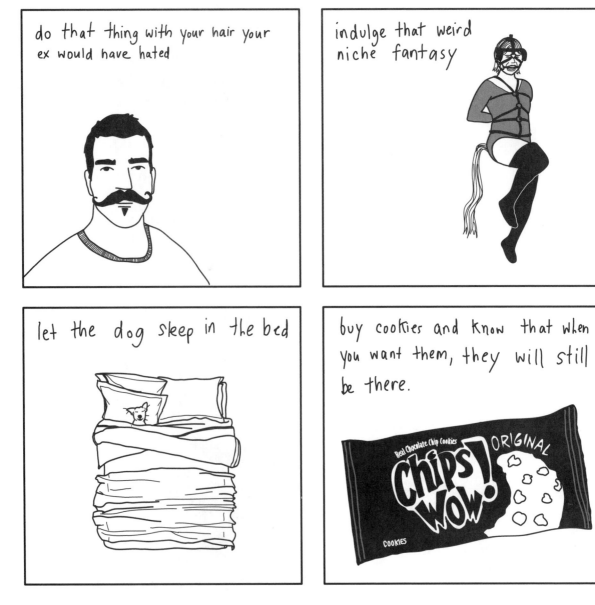

do that thing with your hair your ex would have hated

indulge that weird niche fantasy

let the dog sleep in the bed

buy cookies and know that when you want them, they will still be there.

DRAW YOURSELF IN THIS MASSIVE BED THAT IS
ALL YOURS

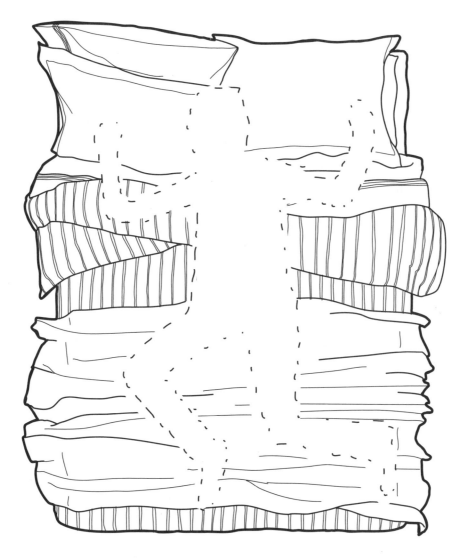

WORD SEARCH:
THINGS THAT ARE BEST ENJOYED ALONE

Get ready for some new hobbies, you disgusting little monster.

EARWAX RETRIEVING
MASTURBATING
TV BINGEING
HANDSTANDS
ADELE SINGING
CALLUS MICROPLANING
SELFIE TAKING
PIZZA ORDERING
MIRROR DANCING
NATURE WALKS
KNITTING
PIMPLE POPPING
MEDITATING
BURRITO EATING
SWIMMING
SLEEPING
GROCERY SHOPPING
ENYA

```
B K C J W L S Q S G V P M X I H S H E W X V T R B Y T U A G
P U N C K W L C W S N E F G N L M L K Q P U Q K A T B D E N
U J R I R M R K I S E I M N E D W T C M P P V U U Z E Y W I
O Y J R T V C I M Q X G P E R H K U H H A F S E F L N J T E
S E T J I T S T M B S B P P G N I K A T E I F L E S Q T S G
A K A W O T I B I I W I G H O C N S Y K E F G S I F A N S N
R F L N D H O N N X N Z G Q Q H K I S Y F W I K I C S R G I
G L K A O U I E G G O X Z O P C S R Y Y Z N H W W H Q N O B
E S M V W G A G A R H I B F Z A P Y T E G E W L O C I K F V
I P J B X E V D E T Y G B K H L J W R I B P Z R W C S K E T
F J M J U Z R F R S I F E H M L G C N E P N I L N Z K B M K
O I A P R J M U U M E N R O B U W G P B C X N A H H T L E U
Z G S U H W K Z T B R V G E A S L B I J H O D F I L Y M R W
Q C T J Q V W A A A V R H S D M A Y M C T R R B L L I R S P
J Q U Y R C R L S J N G D U G I W E O Q O B A G T G S Q K Y
W V R C Q X P J C X Q N F Y H C A X N R F G U S C S Q X R N
X F B J T M C H K I A I G Z I R D O R F F R L L F T G D I H
C I A N O Z W S W T V R K F W O H I D Y J U U M M Q Z Z X U
N Q T L X H G Z S H D E Y A M P M I T D X A A U W S N T A K
F O I D V R G D F G A D X W T L A Y N E A T M M A J I I P H
K L N N K Y N N L H R R R H C A P D J P Z M C L N Y T P U D
P G G X X A B Q P N E O N M G N I L B B I N L I A N E O T G
Y C L O H P O W B T F A M E D I T A T I N G W D V B Y O H B U
U W A E E I B Y R H U Z O L F N U D X J C J C M E H E A J K
Y U E X B S Q I C X X Z F G G G Z T F O T W Z F X F Z K C M
S U L I W X E O J P G I W Y Q Z I U P V Q M B H F F Q I V H
W Q I T V V V Q K N C P I M P L E P O P P I N G A Y C Z Q M
P N H E I U L L G G Y K F Y I A F R F H T H V B V K X R N B A K
Q Z O N D R P T O M E M L X Y L Y O T R F A V H I C P H M H
F Y G H W X C L R U Z S Q W A X H J G K R D O R F N P I H H
```

HERE, PUT EXACTLY WHAT YOU WANT ON THIS PIZZA

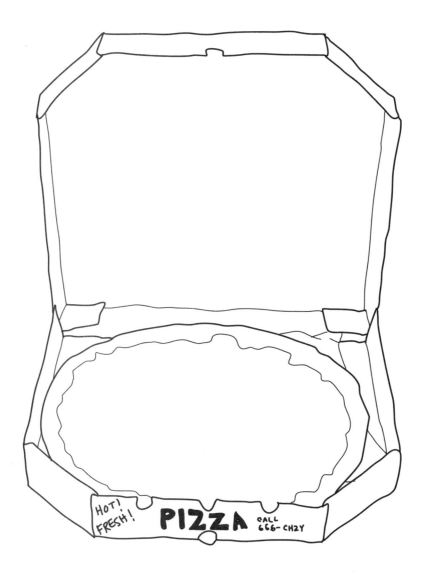

CROSS OUT ALL THE THINGS YOU'RE GOING TO MARIE KONDO RIGHT OUT OF YOUR LIFE

For ages, your bedside table and medicine cabinet and refrigerator have been filled with your ex-partner's things, sitting there and taking up room while doing absolutely nothing for you personally. Cross out everything that you're about to toss (and circle the things that get to stay, because they're yours now).

Propecia prescription bottles

Tampons

Protein powder

Keto cookbooks

Never-used Peloton

Sprinkling of hairs from razor

Just For Men

Ear-hair clippers

Lady Bics

10,000 half-used, expired lipsticks

10,000 half-used bars of soap

Way, way too many batteries

All the throw pillows

Also all of these things:

HOW TO:
THROW A DIVORCE PARTY

Hey, you probably started this whole deal with a party, so why not send it off with one? Even if you don't feel like celebrating, tequila has a tendency to make a person either dance on a table or cry, and both of those (at the same time?! why not!) are totally acceptable life choices right now.

TRY ONE OF THESE THEMES

Lemon Party

Because you took lemons and made them into . . . right, you get it. Also anytime you can work Beyoncé into a theme, you know it's a good one.

Pay for My Therapy Party

Guests are encouraged to leave any and all unsolicited opinions at home and bring checks instead.

Rock Bottom Party

Dress as your favorite has-been '80s rock idol, but maybe skip the hard drugs.

Monster Party

Everyone should dress up as their favorite scary villain. You, naturally, will come as your ex.

DRAW YOU, HAPPY AS A FUCKING CLAM

← your face here

← Choose your own adventure

CIRCLE THE THINGS THAT ARE MOST IMPORTANT TO YOU RIGHT NOW

cats!

your favorite pillows

Waterproof mascara

Easter candy

croissants

sheet masks

coffee

team sports

"vitamins"

DRAW A NEW TATTOO ON BEN AFFLECK'S BACK

If you haven't seen the post-divorce tattoo Ben Affleck got, google it immediately. It's not cute. We'll wait.

Now do Ben a mitzvah and draw something better on him.

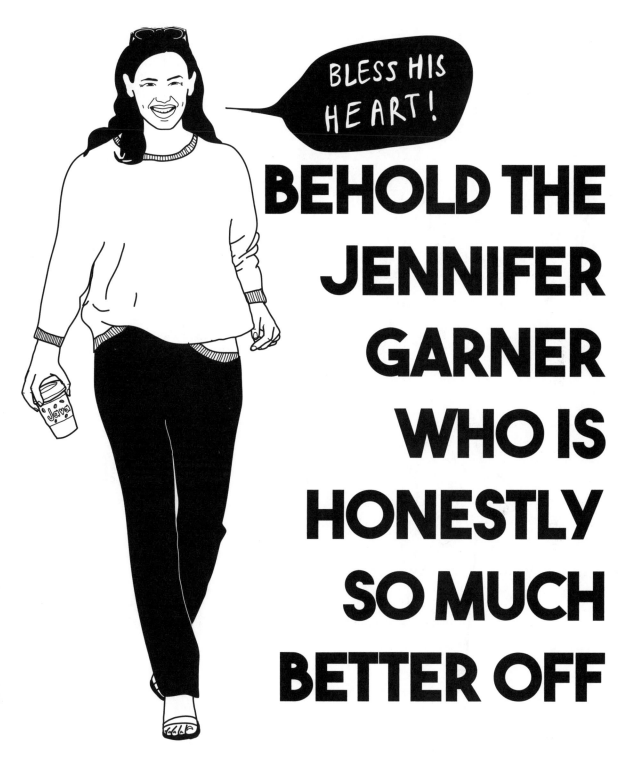

ex's college sweatshirt

a power suit

a thong

an adult
onesie

20-year-old
leggings

TOP FIVE

YOUR FAVORITE THINGS TO WEAR RIGHT NOW

a boxing uniform

1. _____
2. _____
3. _____
4. _____
5. _____

Journal

I'm currently dressing for:
 a) Comfort
 b) Sex appeal
 c) Vengence
 d) My lawyer
 e) My therapist
 f) My cat

Honestly, if I could just live in this it'd be swell:_____

But when it's time for me to Get Out There Again (eeeeeeeeeeek), I'm going to wear this:

DRAW YOUR FUTURE

YOUR MINI SLAM BOOK

*Go ahead: Write down all those things you know you *shouldn't* say to your ex, but reaaaaaaaaally want to. We won't tell.*

talk shit here

GENERATE A CODE NAME FOR YOUR EX

Hearing an ex's name can be painful, so go ahead and skip that part. Besides, it's much more fun to gossip with your friends about Feral Potato.

	FIRST LETTER OF YOUR EX'S FIRST NAME	FIRST LETTER OF YOUR EX'S LAST NAME
A	Screaming	Monster
B	Slippery	Potato
C	Baffling	Goat
D	Snotty	Loaf
E	Grumpy	Icicle
F	Spiteful	Mistake
G	Curdled	Smegma
H	Broken	Glue
I	Crusty	Sofa
J	Wretched	Medusa
K	Infamous	Disease
L	Drippy	Wart
M	Bulging	Spaghetti

N	Heinous	Chupacabra
O	Dirty	Hole
P	Itchy	Jackalope
Q	Wet	Vortex
R	Icky	Horror
S	Hairy	Troll
T	Bitter	Amoeba
U	Ruthless	Urinary Tract Infection
V	Exhausting	Beast
W	Feral	Blob
X	Jiggly	Giraffe
Y	Poopy	Hangnail
Z	Limp	Taint

NOW, JUST FOR FUN, WRITE THEIR CODE NAME IN ACTUAL CODE:

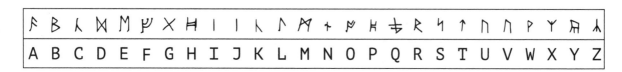

HOW TO:
HANDLE GOING TO A DINNER PARTY WITH ALL MARRIED COUPLES

You know how they say that divorce is "catching"? It's true: When your married friends see you gallivanting around with your luvahs, having time off from the kids, and getting to spend your own money on whatever the hell you want, they will catch a case of FOMO for the ages. Which means that if they deign to invite you to an otherwise couples-only dinner party, you're going to need to tread carefully.

HERE ARE SOME SUGGESTIONS:

Come prepared	Make sure to have at least three dating horror stories. Remember, you were invited for a reason, and that reason is: Entertainment.
Look down	Do not smile at any coupled-up attendees of your preferred romantic gender, even if they pass you the salt, because their partners are one thousand percent on the lookout for material to fight about once they get home. No peeking; no acknowledgment of any kind. You are now officially Dangerously Sexy.
Lie	Unless you're craving the sound of crickets, do not mention how much better life is now (even if omg, it really is).
Lie some more	Frequently exclaim over how amazing everyone else's relationship seems to be. Their marriages are nothing at all like yours. That fight that Kevin and Alice just had over who handles more of the emotional labor in their family is totally unrecognizable.

HERE, PLANT YOUR OWN FLOWERS

"I used to hope that you'd bring me flowers. Now I plant my own." —Rachel Wolchin

TOP FIVE

WOO-WOO SELF-CARE ACTIVITIES YOU'VE TRIED

Crystal healings! Chakra readings! Trips to small islands off the coast of Peru to participate in ayahuasca ceremonies! It's really the big question any divorced person should be asking themself: WWGD*? List all the (probably) Goop-approved activities you've employed in an effort to be the kind of person who does, in fact, consciously uncouple.

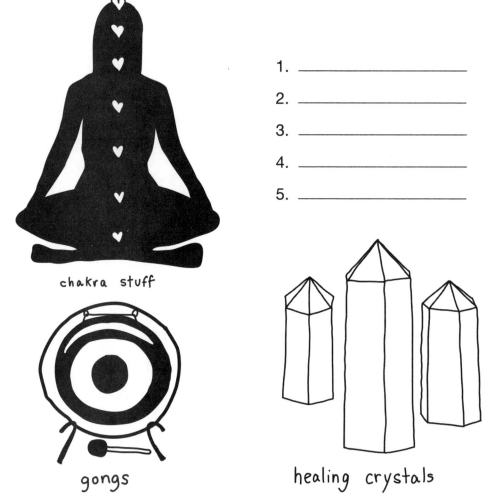

chakra stuff

gongs

healing crystals

1. _____

2. _____

3. _____

4. _____

5. _____

*What Would Gwyneth Do, of course.

GET FROM MORNING TO NIGHT WITHOUT LISTENING TO OTHER PEOPLE'S TERRIBLE ADVICE!

AVOID <u>DR. PHIL</u> RERUNS! CAROL FROM HR WHO "ISN'T SURPRISED"! YOUR MOTHER WHO IS WELL-MEANING BUT *JESUS*, MA!

FOUR INTERIOR DECOR STYLES TO TRY

Moving out? Staying where you are? Either way, you're about to have allllll the say over what your place looks like. Just imagine the possibilities.

BACHELOR/ETTE MANSION

Things are about to get spicy up in herrrrrre. You need silk sheets. Low lighting. A stripper pole? Why the fuck not.

THE OPPOSITE OF WHAT YOUR EX WOULD WANT IN LITERALLY EVERY WAY

Pretty, pretty pink sheets accessorized with throw pillows appliquéd by your beloved Grandma Ida? An entire universe of Avengers figurines waging an epic battle on the kitchen table? And is that a stack of pizza boxes, or a glamorous modern art installation? YOUR CALL, DARLIN'.

FUCK IT

Cat hair? Check. Stack of cried-upon Jacqueline Susann novels? Sure. Dirty laundry-as-seating option? Obviously.

COMPLETELY AND TOTALLY EMPTY

Sure, this might be because your ex got all the furniture, but on the bright side: Space, delicious space. Breathe it in.

THANK U, NEXT

1 SKY BLUE **2** LIGHT GREY **3** WHITE **4** LIGHT BROWN **5** DARK GREY **6** DARK RED **7** EARTHY YELLOW **8** LIGHT GREEN **9** MEDIUM GREEN **10** BRIGHT RED **11** BLACK

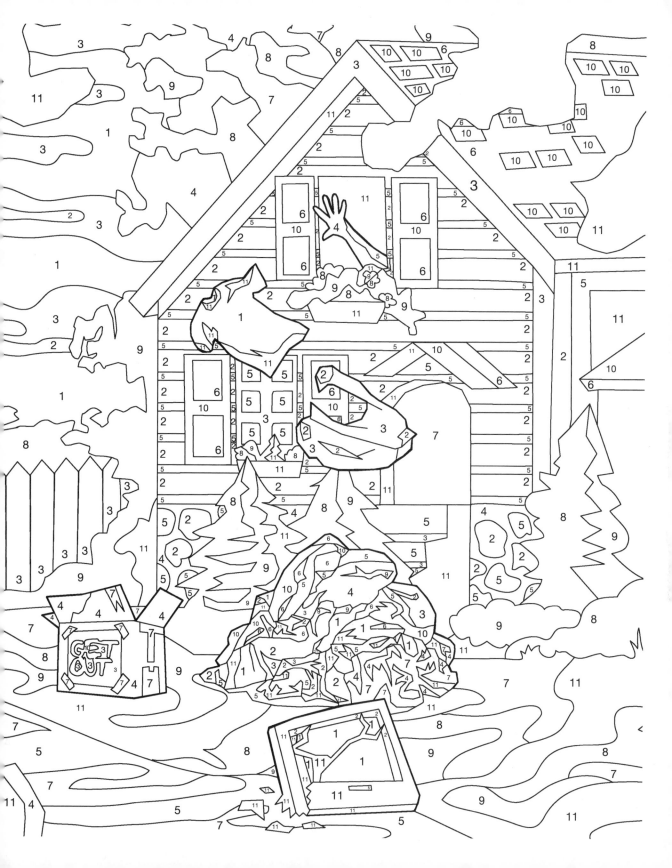

Eventually, we all reach a saturation point: We've shed the tears, we've obsessed over the what-ifs and maybe-buts, and we're ready to put away the tissue box, throw on some pants (imagine), and do the thing that's both mind-blowingly exciting and utterly terrifying: Get back out there, preferably with Gloria Gaynor playing in the background. This, by the way, does not necessarily mean "dating": It can be something as small as a drink with a friend IRL, as opposed to over text because getting out of bed is hard. It's especially important to remember that while a new partner might be nice—emphasis on "might be"—they are not necessary. You are living proof.

You may be wondering, "But . . . will anyone find me attractive?!" The short answer is "Yes, obviously, you are spectacular," but in case you're extra anxious about this issue, here's a quick rundown of reasons you're an even better catch now than you were in your younger years:

Flailing marriages don't tend to put people on cloud 9, so you're probably happier than you've been in ages.

You have your priorities straight. You know that marriage isn't the end-all, be-all, and that finding a true partner who you enjoy spending time with is what's important.

You're exhausted by the idea of playing games. Bonus: The people you're dating probably are, too, because no one is twenty-two anymore. If you want to call, you're going to call. If you're not interested, you're going to say so. Ugh, so refreshing.

You're way better at sex, and more open to experimentation. Threesomes! BDSM! Something that isn't the missionary position! Or just communicating your needs more clearly! Go for it.

You're braver. You've now done the thing that scared you the most—the thing you thought might kill you—and went ahead and survived it. Now you know: You can survive anything.

This is your opportunity to figure out who you are, and what you want. Do you all of a sudden find yourself fantasizing about dating with zero commitment? Joining a polycule (it's a thing! See page 101)? Moving to Alaska and interacting exclusively with reindeer for the rest of your days?! All of this is valuable information. Now is the time for zero expectations, zero obligations, and a whole lot of fun.

DIVORCED PEOPLE WHO ARE LIVING THEIR BEST LIVES

Leveled up to a Prince; toppled the monarchy.

Meghan Markle

Fell in love with an awesome rocker chick; became King of New Jersey.

Bruce Springsteen

Became J.Lo; Fucking destroyed it

Jennifer Lopez

Became Buddhist; Sold millions of albums; moved to Switzerland

Tina Turner

Wrote bestselling memoir; continued charming all of America

Amy Poehler

WORD SEARCH:
MORE THINGS TO AVOID ON THE APPS

Nope, nope, and nope to these.

SHIRTLESS SELFIES
GHOSTERS
MANSPLAINERS
BURNING MAN PICS
ENTREPRENEURS*
PHOTOGRAPHERS*
INFLUENCERS*
PHISHHEADS
FEDORAS
PEOPLE WHO JUST WRITE HI
AGE LIARS
REQUIREMENT LISTERS
CONSTANT MESSAGERS
PYRAMID SCHEMERS
CRYPTOCURRENCY PUSHERS
MARRIED PEOPLE
RELATIVES

*These are all code for "unemployed."

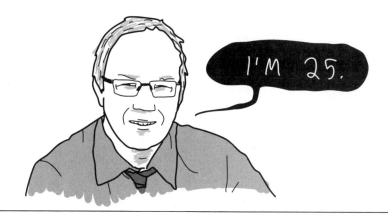

```
S M Q D M U A X Y D S S S X M C S R M W P N H L E X W R S Y C
E R Y V H L I G Y B E R A R R H S D P I I L S F I U X E R T
S U E Q F W Y Y E V P R E E F O J S Y L Q H I C I I Y Y P C
V E P C E T I I I L R U M T X D G A G I B R P P N R P O H F
R R N J N J N T D I I E D Y S N J D C X C N K P D T F J O F
I X R T F E A T E R H A J M G I L P F Y Z G S K O Z H U T T
L S H B R L U D J C Q T R E P N L P O V F O X C V N V N O S
W D D W E E P L S V B Y N S R O U T L S A N U E H I X G G M
P Y X R P E P D F G H O S T E R S L N C R R R J B R D Q R N
X Y J T O R I R D N A V W G S A W G V E R K W C X V B O A Y
T J R P P M W Z E B I D K E K X W P B E M M X S P R G E P T
V D L O A Q D M D N K V R W T F H X N G J E L Z I I D K H Z
U E R R B K Q X Q F E V A L J T G C B A P G R J D D F D E S
N O Y T G Z T O W C S U Y H T I Y O I H G U Y I P B C Z R D
X P X L K I A N K W S O R F X P P Z R M E X P D U F Z W S A
Z A T D W O U P B R N B U S U G A K K Q F Z R H E Q M D E E
A W E B Q I H E T I R W T S U J O H W E L P O E P Z E Z I H
I C D G O D M M V N B F H M T C H Y S T F W Y D E D C R F H
C A J G K I G J R M X E J B U R N I N G M A N P I C S G L S
G J Z S J S C A O A R O S X R L O Y O T U W J E Q K T G E I
U W X J V M S N H C S L D E K U S B K A K C C Q T P I H Y S H
S Y V L V V S X N B J G U M N P Q M H I M A S F Q L U C S P
B K S D W R M B O M V F R Q E X Q V I G K L C L R H S E S R
V U J H D C T P D V V S R E N I A L P S N A M V E U F V E M
O U Q V C U J V Q T V S N P A H R W J D U T I O O E L L K
B E V B Z W H C U C Z F C N C Y F Q N O B K U N A C D E T B
H R E Y K G Y O Z O K I Q D G D K M K H F L R O P X O M R M
U X I Y V P U A I Y L D A G S E W E V G H Y N N U U R J I E
N Q U V N D L C T S B I V E Q X R J Z G O C B T H E A I H Y
Q W Q I A O I F R V S N K V O Y V U A M I C G T U E S U S A
```

MENTAL HEALTH
CHECK-IN:

Today is: ___/___/_____.

I'm feeling _____.

The worst part of my day was: _____

_____.

The thing that I did to make myself feel better was: _____.

Here is something I did today that I'm proud of: _____

_____.

For that, I deserve a: _____.

I also did these things, which are great: _____

_____.

I made someone else's day better by: _____

_____.

Now that I think about it, today was pretty lovely.

DRESS THIS STICK FIGURE FOR A WILD SINGLE-PERSON NIGHT OUT

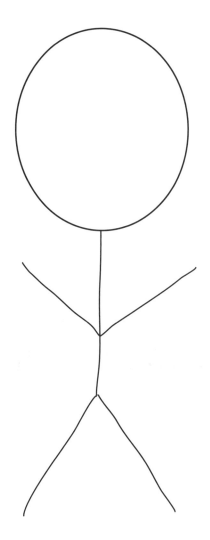

QUIZ:

WHICH DISNEY CHARACTER SHOULD YOU DATE?

What I'm looking for in a partner is:
 a) Hot parent with great hair
 b) Owns a castle
 c) Adorable and mute
 d) Super sexy, job optional
 e) Impossibly roguish charm

My favorite sport is:
 a) Bounding through open plains
 b) Hallway pacing
 c) Swimming
 d) Parkour
 e) Bedeviling all those who lay eyes upon me

My favorite thing to eat is:
 a) Meaaaat
 b) Whatever my personal chef whips up
 c) Plants and plant-related things. Definitely not sushi.
 d) Honestly, all food is good food
 e) A pint and some shepherd's pie

On a first date, I like to wear:
 a) Something I can get sweaty in. (Not like that, come on.) (Okay, maybe like that.)
 b) Black-tie
 c) Something cute and sporty that says "I am so down to earth and dateable!"
 d) Whatever's comfortable; I don't really care
 e) A dashing *ensemble*

88

My dream vacation involves:
- a) Glamping
- b) Jetting off to an island somewhere. Preferably in my own plane, and to my own island.
- c) A beach and a drink and a paperback romance
- d) Rock climbing/white-water rafting/the extreme sport of my choice
- e) Gazing into the eyes of my one true love

I hope to be remarried again:
- a) Right. Now. PUT A RING ON IT
- b) When someone can afford me
- c) When I fall in loooooove
- d) When I get (literally) swept off my feet
- e) When I meet a super-sexy cartoon fox

DRUMROLL, PLEASE:

Mostly As: Mufasa. HOT, albeit currently chilling on the spiritual plane (aka "dead").
Mostly Bs: Beast. HOT, albeit problematic (Stockholm syndrome, heyyyy!).
Mostly Cs: Ariel. HOT, albeit problematic (GIRL. Do not give up your life, family, and voice for a dude you just met).
Mostly Ds: Aladdin. HOT, albeit unemployed.
Mostly Es: The fox from *Robin Hood*. HOT, without qualifications. Also congratulations, you are everyone, because everyone has a crush on the fox from *Robin Hood*.

Journal

No but seriously, the next person I date should be _____

_____ , and must under no circumstances _____

_____ .

My flexibility level, on a scale of 1–10: _____

GET THROUGH THE DATING APPS WITHOUT CRYING

AVOID 12-YEAR-OLDS TRYING TO CATFISH YOU! PEOPLE POSING WITH DOGS THAT AREN'T THEIR OWN! ANYBODY WHO THINKS IT'S OKAY TO USE THE DROOLING EMOJI!

—SUCCESS!—

PICKUP LINES YOU SHOULD PROBABLY NOT TRY

These are terrible. So terrible, in fact, that they're kind of amazing.

Well, here I am! What were your other two wishes?

I'm sorry, were you talking to me? No? Would you like to?

Are you a Wi-Fi hotspot? Because I feel a connection.

Are you my appendix? I don't know what you do or how you work, but I feel like I should take you out.

If you were a Transformer, you'd be Optimus Fine.

Are you into conspiracy theories? Because I wanna get illuminaughty with you.

Excuse me, I think you have something in your eye. Nope! It's just a sparkle.

Are you a campfire? Because you're hot and I want s'more.

Hey, my name's Microsoft. Can I crash at your place tonight?

Was your mother a beaver? Because DAM.

THE BEST PARTS OF DATING WHEN YOU'RE A LITTLE (OR A LOT) OLDER

1. You've both probably picked up some basic life skills along the way, e.g., vacuuming, laundry, career-having, etc.
2. You probably both have more money, so you can do more cool stuff together. You also probably both have a lot more shit you have to pay for. Ignore that last part.
3. They don't want to go out to a club, either.
4. You can try to remember words together. It's kind of like a game!
5. Grey hair can be super hot. Here's looking at you, Anderson Cooper.
6. You can make decisions and actually, you know, stick to them. Kinda.
7. You probably don't have roommates who are loudly farting whilst playing Dungeons and Dragons in the living room at all times.
8. More life experience = lots more stories, adventures, and ways to get to know each other. (How did we ever make actual conversation with twenty-year-olds?)
9. Whomever you're dating has probably had more sexual experience, which means that people have already patiently explained to them what to do (and not do) to make their partner happy in bed.
10. The "three-day rule" and other pretend garbage that teenagers made up doesn't apply anymore. Text away!
11. They probably know how to cook something besides boxed macaroni and cheese.
12. You're both less likely to wake up with dried spittle on your cheek and a raging hangover.
13. You both know exactly what you want, and if it's not right, you won't waste each other's time.
14. You're both statistically less likely to own and/or sleep on a futon.
15. They can sympathize with your chronic back pain and bad knees.

Journal

How I feel about "getting back out there":

a) Excited
b) Nervous
c) Happy anticipation
d) Not-happy anticipation
e) Full-stop terror
f) Like I need a nap
g) Like I need a drink
h) Like I need a hug from Oprah

My ideal first post-divorce date involves:

a) Getting invited over to their mansion, whereupon I will eat caviar, drink champagne, and have lots and lots of sex on their helipad.
b) VEGAAAAASSSSSS!
c) A dinner I don't have to pay for, woohoo!
d) Xanax
e) By "date" you mean "DVR," right?

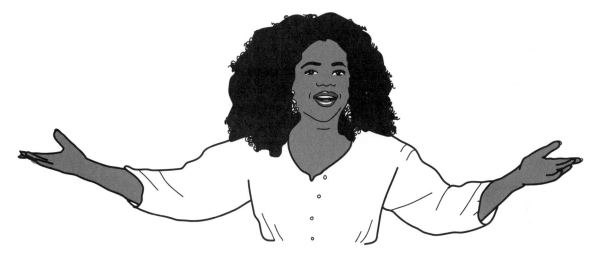

I have/have not already gone on a date. Here is how it went: _____

This makes me feel: _____

UNSCRAMBLE THE STDS YOU'RE NOT GOING TO GET!

Here's a weird, not-so-little problem you may encounter over the course of your post-divorce sex adventures: The people you date may be older than they were your first go-round, and may also be divorced themselves. And for some terrible reason, many individuals in this population appear to be allergic to condoms. Perhaps they're out of practice? Or are assuming you're safe because you were until quite recently married? Whatever, there is no excuse.

Remember: If they're not suggesting using protection with you, they're not suggesting using protection with <u>anybody</u>.

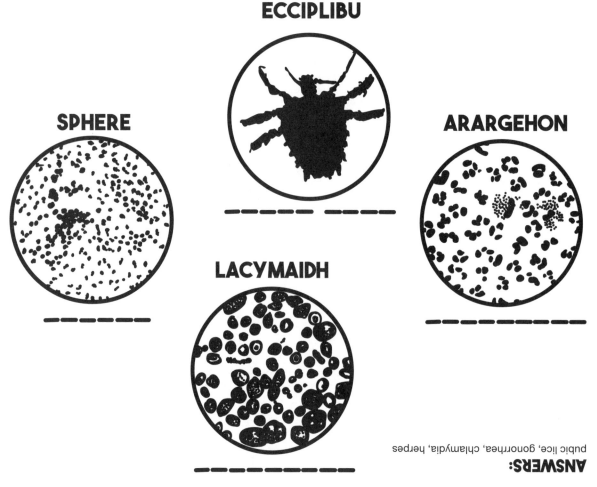

ECCIPLIBU

‒‒‒‒‒ ‒‒‒‒

SPHERE

‒‒‒‒‒‒

ARARGEHON

‒‒‒‒‒‒‒‒‒

LACYMAIDH

‒‒‒‒‒‒‒‒‒

INSTEAD OF THAT, TRY THIS!

INSTEAD OF . . . TRY . . .

INSTEAD OF . . .	TRY . . .
A one-night stand	Binge-watching *Fleabag* while eating an entire box of Oreos
Exercising, ugh	Sobbing violently (great for core strength)
Taking up smoking	Taking up competitive dog grooming
Tinder-swiping	Moving around furniture to see if it'll look better somewhere else, then moving it back to where it started
Cuticle-destroying	Wrapping rainbow yarn around horseshoes and starting your own adorable Etsy business
Drinking an entire fifth of Bacardi	Making yourself one of those fancy health elixir shots with lemon and cayenne pepper (equally high chance of making you vomit, but technically better for your kidneys)
Speed dating	Buying an excessive number of houseplants and watching them very slowly grow
Instagram stalking your ex	Deleting Instagram entirely (and Twitter! And Facebook! BURN IT DOWN)

Journal

My absolute worst post-divorce habit is: _____

I think instead I'll try: _____

HOW TO:

LEAVE THE BAR YOU DO NOT WANT TO BE IN

Remember how going out used to be fun? And then remember how you stopped going out, ever, because married people have a tendency to forget how to do things like socialize and also why are bars so loud?

It's likely that you have a few friends who'll be all "But you're SINGLE now!" and try to drag you out for a cocktail or twenty. Here are some ideas for making a quick exit when you're over it.

GET OUT:

Eat a thing. Start having an "allergy attack" to that thing. If you can make your cheeks swell on cue, do.

Explain why this restaurant reminds you of your ex. Explain why this drink reminds you of your ex. Explain why the song playing reminds you of your ex. Oh no, the server totally reminds you of your ex. Give lots of details. When you suggest calling it a night, other people will be super cool with that.

Tom just LoVED umbrellas...

Omg you just missed a call. Omg it was your lawyer. Omg it's too loud in here for you to call her back. OMG YOU BETTER LEAVE.

Just cry a lot, and wait for someone to suggest you go home and lie down.

YOUR FIRST POST-DIVORCE DATE

Hand this page over to a friend, who will prompt you for each blank, then read your creation out loud.

_____ and I met on _____ , which was
RANDOM NAME DATING APP

_____ . They said they've only gone on dates with _____ other
ADJECTIVE NUMBER

people from there. They're a/n _____ , a perfect match for my _____
ASTROLOGICAL SIGN ADJECTIVE

personality. They live in a _____ in _____ , a place known for its
TYPE OF BUILDING CITY

_____ that I've always wanted to explore. We immediately bonded over
PLURAL NOUN

our mutual love for _____ , our fear of _____ , and our history of
PLURAL NOUN PLURAL NOUN

competitive _____ . I checked out their _____ , and they mostly post
HOBBY SOCIAL MEDIA CHANNEL

about _____ , _____ , and _____ ,
PLURAL NOUN PLURAL NOUN VERB ENDING IN -ING

which is _____ .
ADJECTIVE

It's a really _____ day, so we decided to go to _____
ADJECTIVE PLACE

to _____ for awhile. I'm going to wear a/n _____ and a/n
VERB ARTICLE OF CLOTHING

_____ . I'll carry a/n _____ so they know it's me. After we
ACCESSORY OBJECT

_____ we're going to head to _____ to _____ .
VERB PLACE VERB

Who knows, maybe we'll even try _____ !
VERB ENDING IN -ING

I am so _____ .
EMOTION

A PEEK INSIDE YOUR OPEN MIND

So many adventures lie ahead of you! Go ahead, draw a few.

ETHICAL NON-MONOGAMY:
IT'S A THING!

Was the last time you had non-married sex in a dorm room? Did Tinder even exist back then? Sit down, because you are in for a surprise: Ethical non-monogamy—an umbrella term that includes a wide variety of relationship styles that aren't strictly monogamous—is big, and getting bigger every year. Perhaps it's an increasing awareness of just how unrealistic a traditional, long-term monogamous relationship is for many people, or perhaps it's simply an increasing trend toward open-mindedness, but regardless of whether this lifestyle is for you, it's fun to know what the kids are up to these days.*

Match the term to its definition, and prepare to blush.

*Why include the word "ethical"? Because it conveys that all parties are being treated respectfully, with across-the-board mutual consent. Unethical non-monogamy, in other words, is called "cheating."

JUST CALL US "THE ETHICISTS": a) 8, b) 6, c) 9, d) 5, e) 4, f) 2, g) 10, h) 7, i) 3, j) 11, k) 1

a) Polyamory

b) Open Relationship

c) Monogamish

d) Polycule

e) Hierarchical

f) Relationship Anarchy

g) Compersion

h) Metamour

i) Sex Positive

j) Soft Swap

k) Consent

1. Characterized by asking for and accepting only an enthusiastic YES as a green light before taking any action.

2. A structure where no partner's needs come before any others and positions can shift freely.

3. An umbrella term for the normalization of sexual variation and celebration of all the ways one can be a sexual human being.

4. A polyamorous relationship that honors the primary couple above other secondary or tertiary partners.

5. A group of people who have sexual, emotional, and friendship bonds with one another. Not all members are necessarily sexually connected, but they often are by one degree. It's like *Grey's Anatomy*, but with fewer scalpels and more potlucks.

6. A flexible term that simply means your relationship doesn't rule out having other partners or even other relationships.

7. Your partner's partner. A word that honors the unique relationship between two people who both have a sexual/romantic connection with the same person.

8. The practice of engaging in loving, often committed, relationships with multiple people at once.

9. A mostly monogamous relationship with some romantic and/or sexual wiggle room (e.g., a hall pass or an occasional spree).

10. The opposite of jealousy; a feeling of genuine happiness for your partner's connection with another person.

11. A practice wherein two couples swap partners, without allowing for penetration. Often a first step for newbies.

SHOULD YOU HAVE SEX?

To get naked or not to get naked: 'Tis an excellent question. Use this handy flowchart to find out whether you should, indeed, have sex right now.

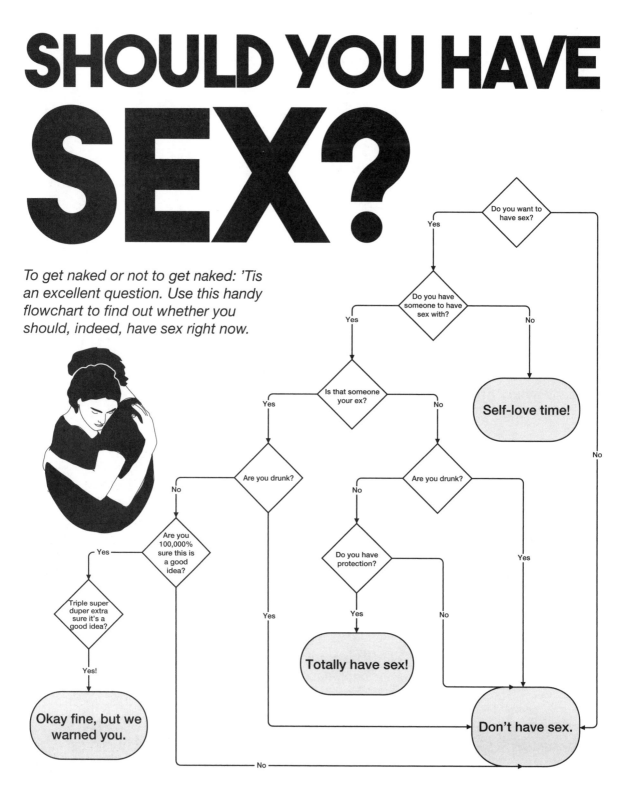

Do you want to have sex?

Do you have someone to have sex with?

No → Self-love time!

No → Don't have sex.

Yes → Is that someone your ex?

Yes → Are you drunk?

No → Are you drunk?

No → Are you 100,000% sure this is a good idea?

Yes → Triple super duper extra sure it's a good idea?

Yes! → Okay fine, but we warned you.

No → Don't have sex.

Yes → Don't have sex.

No → Do you have protection?

Yes → Totally have sex!

No → Don't have sex.

Yes → Don't have sex.

AS A GENERAL RULE OF THUMB . . .

IF IT'S YOUR EX

DON'T HAVE SEX

REASONS YOU DON'T NEED ANYONE ELSE TO BE HAPPY

Perhaps you've noticed by now that one of the most common pieces of advice people will offer the newly divorced person is that they should take this opportunity to "learn how to be alone." Which may not be what you want to hear, because "learning how to be alone" sounds 1) like work, ugh, and 2) depressing. Also will everyone *please stop* telling you what to do?

But while much of the advice you will be gifted in the period following a divorce will be both annoying and unhelpful, this particular piece is, well, still annoying—but it's also wise. A common theme among philosophers, self-help gurus, and other smart people like Kelly Clarkson is that the greatest lessons are learned during the hardest times, and it's true: When the noise of a flawed relationship has suddenly gone quiet, you have the opportunity to discover new truths.

You may learn that resentments, grudges, and jealousy hurt you way more than they hurt anyone else.

You may learn that if you are patient and allow time to pass, it will heal you.

You may learn that you can do hard things.

You may learn that you—just you, just as you are—are enough.

And finally, you may just learn that what doesn't kill you makes you stronger.

Thank you, Kelly. You were right.

GET TO YOUR HAPPY PLACE

AVOID YOUR EX'S ANGRY EMAILS! COLLEAGUES TRYING TO SET YOU UP ON BLIND DATES! ANYONE SUGGESTING YOU JOIN THEM FOR A SPIN CLASS!

LET'S GO

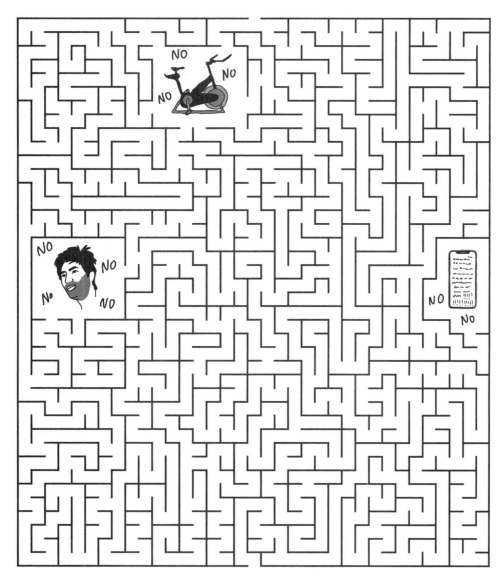

GOOD JOB

pick a star. make a wish.

WHAT REALLY MATTERS

Low interest rates
kitten meows
Moisturizer
Deli pickles
High-speed WiFi
Video chats with family
Very old t-shirts - - - -
Super soft sheets
Your first stuffed animal
Ramen soup, made right
Beach runs with dogs
Dogs! woof
kids

Parents
Grandparents
Getting up early to watch the sunrise
New books
Childhood friends
Vegetable gardens
Classical music on the radio
History
A bath, a book, a candle
Past memories
Future hopes
This place:
This person:
This random thing only I understand:
These things:

Magic

DRAW THE FOUR PEOPLE WHO SAW YOU THROUGH THE WORST OF IT

In our darkest times, we're sometimes surprised to find unexpected avenues of support. Maybe your brother has really been there for you. Or your former college professor. Or your Postmates delivery lady. Show your personal heroes some love.

Why I love them: _____

Why I love them: _____

Why I love them: _____

Why I love them: _____

PRIORITIES

You may have noticed that your priorities have shifted a touch lately. We hope that anything you consider self-care is at the very top of that list, whether it's stewing bone broth, getting your teeth professionally whitened, or camping out under the great big sky.

Place each of the words or phrases below into the appropriate column on the right. (We put "Pasta" in the correct one for you.)

Under-eye concealer, gym membership, pasta, good advice, sweatpants, Chinese food delivery, Tylenol, fancy dinners, leaving the house, a clean kitchen, my lawyer, my therapist, self-help books, cooking shows, Instagram celebrities, YouTube videos of overweight cats, a brand-new journal, jigsaw puzzles, calming lighting, Netflix, hiking in the woods, coffee, vacation days, tarot, best friends, fresh new highlights, my phone, Zoom happy hours, walking in the woods, meditation, my career, scented candles, anti-wrinkle cream, my friends, new underwear, a hairbrush, Zoloft, clean sheets, physical human contact, my mother, this activity book

THINGS I CAN'T LIVE WITHOUT

THINGS I DON'T GIVE TWO SHITS ABOUT

pasta

DIVORCE BINGO

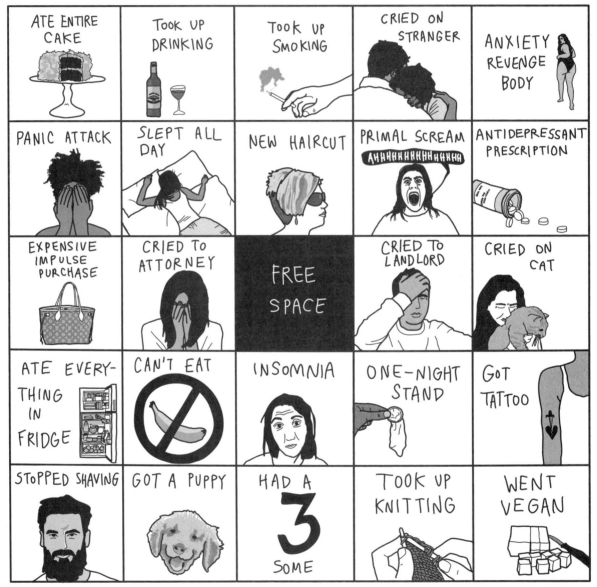

THE DAY MY PAPERS WERE SIGNED

Hand this page over to a friend, who will prompt you for each blank, then read your creation out loud.

I walked into _____'s _____ and sat on the
 PERSON ROOM IN HOUSE

_____ . I was _____ , but I was wearing my lucky
 PIECE OF FURNITURE EMOTION

_____ , so that helped. There they were: my _____ ,
 ARTICLE OF CLOTHING ADJECTIVE

_____ divorce papers. They handed me a _____ , I picked
 ADJECTIVE NOUN

up a _____ , and I started _____ . The thing was
 NOUN VERB ENDING IN -ING

_____ pages long, so I went through a lot of _____ . I got to keep
 NUMBER PLURAL NOUN

the _____ , the _____ , and the _____ ,
 NOUN NOUN NOUN

but had to give my ex the _____ and the _____ ,
 PLURAL NOUN NOUN

which made me feel _____ . When it was all over, I wrote them a check
 EMOTION

for _____ dollars and _____ .
 NUMBER VERB, PAST TENSE

My next stop was _____ . I sat down across from
 RESTAURANT

_____ and ordered _____ _____ .
 PERSON NUMBER BEVERAGE(S)

" _____ ," I said.
 EXCLAMATION

" _____ ," they said.
 EXCLAMATION

Yep.

MENTAL HEALTH
CHECK-IN:

Today is: ___/___/_____.

I'm feeling: _____.

Some people I love: _____

_____.

Some places I love: _____.

Some things I love doing: _____

_____.

Something I'm looking forward to: _____
_____.

I also did these things, which are great: _____

_____.

I made someone else's day better by: _____

_____.

Now that I think about it, today was pretty lovely.

AS AN ACTOR WHO PLAYED A WISE MAN IN A MOVIE ONCE SAID...

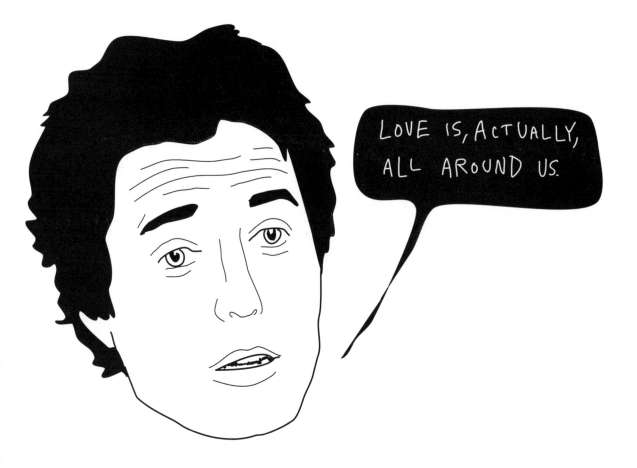

It's a just nice thing to remember.

TILT THE PAGE TO REVEAL A SECRET MESSAGE

THERE'S AN EMOJI FOR THAT

Color in all the emojis that perfectly express where you're at right now. (Caveat: If you feel the need to color in the clown, please put down this book and go call your therapist, because that is terrifying.)

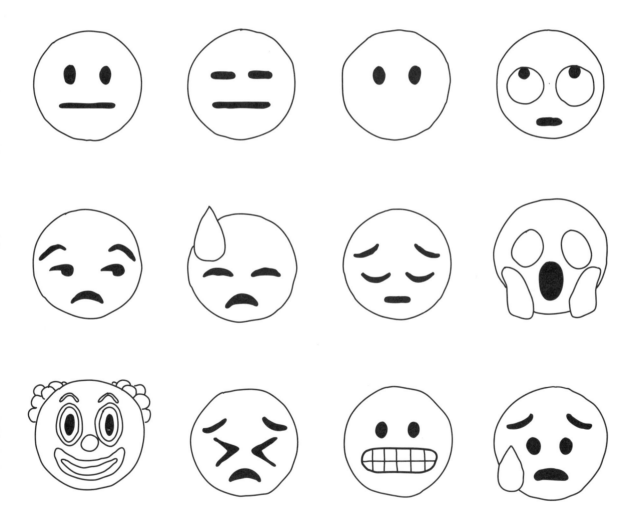

THESE ARE A FEW OF MY FAVORITE THINGS

*Sometimes the simple act of remembering the things that make us feel good can be calming. If this activity doesn't work, try drugs.**

List your favorite things below.

Netflix binge-watch: _____

Instagram account: _____

Podcast: _____

Outdoor sport: _____

Indoor sport: _____

Meme: _____

Human: _____

Reality TV character: _____

Cleaning product: _____

Self-care ritual: _____

Secret habit: _____

Article of clothing: _____

Person to call when I'm happy: _____

Person to call when I'm sad: _____

Early-morning activity: _____

Late-night activity: _____

Ben & Jerry's flavor: _____

Kevin Costner movie: _____

**Kidding! Unless they are legal and/or prescribed to you by a medical professional, in which case go right ahead.*

SPEAKING OF BEN & JERRY'S...

Design your ideal pint!

What's in there? _____

WRITE YOUR NOT-BESTSELLING MEMOIR

Many wonderful memoirs were written in the aftermath of traumatic life events. Hey! You just had one of those! You should write a book! Not a bestselling one, though—you don't need that kind of pressure right now.

*Both authors of this activity book know a thing or two about writing a not-bestselling memoir, so here are our suggestions for how you should write yours.**

DON'T INCLUDE EVERYTHING:
Unless you are an extremely famous human being, in which case please feel free to post about this book on Instagram, you do not need to start with "I was born on a cold, blustery day, the nineteenth of March, to a loving but exhausted woman named Sherry." Start where it gets interesting, and leave the rest out.

TELL THE TRUTH:
Arguably the hardest part about writing a memoir is being 100 percent honest. Writing two hundred pages about how your ex never, ever, ever learned how to throw an empty milk container in the trash may be therapeutic, which is why you should journal, but isn't fun for others to read. Be fearless. Examine all sides of the story, even—especially—when doing so is painful.

SHOW, DON'T TELL:
Instead of simply stating that your ex was a deranged serial killer, describe where and how they hid the bodies. Please make sure that they are imprisoned first.

WHEN IN DOUBT, *EAT, PRAY, LOVE:*
Elizabeth Gilbert is a pro at writing the clear emotional transformation. Her heart breaks, so she eats, then she prays, then she loves again. Try following a similar path in your memoir: How did you get from heartbroken to whole? And if you're still heartbroken, allow that to be a part of the story; don't force a happy ending if you haven't found yours yet. Trust: It's coming.

**If your memoir happens to become a bestseller, please email us and tell us your ways, thank u.*

FOR INSPIRATION, READ THESE MASTERPIECES

Ninety-nine percent of prominent divorce-themed autobiographies were written by women.
If you are a woman, insert your own punchline here: _____.
If you are a man, here's your chance! DISRUPT THE DIVORCE MEMOIR INDUSTRY!

While you're at it, design new covers for these classics based on your own divorce experience.

Wild

Cheryl
Strayed

HEARTBURN

Nora Ephron

HOW
DIVORCE
BECAME
MY
DELIVERANCE

ELONA WASHINGTON

Aftermath

On Marriage and
Separation

Rachel Cusk

SPLIT:

A MEMOIR OF DIVORCE

SUZANNE FINNAMORE

WHAT'S THE TITLE OF YOUR NOT-BESTSELLING MEMOIR?

Eat, Pray, Love has become one of the bestselling divorce memoirs of all time. Why not follow the winning formula?

	FIRST LETTER OF YOUR NAME	FIRST LETTER OF YOUR EX'S NAME	FIRST LETTER OF YOUR HOMETOWN
A	Sleep	Collapse	Melt
B	Breathe	Confess	Expand
C	Leave	Bake	Heal
D	Need	Tinker	Nap
E	Lie	Mangle	Capitalize
F	Fall	Question	Own
G	Relent	Cheat	Begin
H	Despair	Fuck	Achieve
I	Refuse	Repent	Create
J	Steal	Calculate	Relax
K	Breed	Play	Write
L	Juggle	Cook	Deal
M	Justify	Imagine	Jump

N	Quit	Bend	Laugh
O	Enable	Drink	Knit
P	Cry	Explain	Celebrate
Q	Promise	Hug	Explode
R	Serve	Jog	Go
S	Shrink	Chop	Smile
T	Break	Knit	Astonish
U	Consume	Creep	Sing
V	Snore	Adapt	Spend
W	Think	Plan	Grow
X	Resist	Dive	Survive
Y	Wish	Practice	Rise
Z	Stop	Yell	Fly

IF YOU'RE GOING THE *WILD* ROUTE...

Circle the one-word title that best suits you.

Tame Confused Afraid

Bored Asleep

Better Stronger Lost

Happy Free

YOUR POST-DIVORCE FUTURE, CONFIRMED BY ASTROLOGY!

Astrology: The ~~science~~ practice of using the positions of celestial objects to ~~reveal facts~~ guess about stuff that's going on down here on Planet Earth. Read on to discover your 100 percent guaranteed future.

Aries

Look at you, all bold and fearless! Now that you've unshackled yourself from the chains of monogamy, go ahead and lean into your inner bull. If you play the stock market, you will win. Promise!*

Taurus

Taureans enjoy deep relaxation and delicious things. You will develop a vaguely creepy YouTube channel dedicated to the consumption of packaged cupcakes, and get sponsored by Hostess and K-Y.

Gemini

Geminis thrive on glamorous chaos and compulsive occupation. You will decide that ultimate happiness lies in religious meal-planning, obsessive organizing, daily journaling, and the successful completion of 10,000 steps a day. You will achieve these goals for exactly one week, at which point you will decide to just go shopping instead.

Cancer

Cancers are a water sign and also love drama. In your future is a deeply passionate love affair on a tropical beach culminating in a speedy exit, a la *How Stella Got Her Groove Back*. Embrace it—and send us a postcard, you lucky bastard.

Leo

You are true astrological royalty—the Simba of the celestial Pride Lands—and love being in the spotlight. You will be cast in a local production of *Kiss Me, Kate* as "Bystander #2," thereby discovering your true calling in life: Community theater.

Virgo

Since Virgos are already pretty much perfect, you will take this time to go next level by learning to ferment your own probiotic sauerkraut and use fabric recycled from old soda bottles to hand-stitch clothing for orphans.

*We are kidding. Do not sue us.

Libra

Libras are represented by the scales, which means you will 1000 percent win at everything. Book those tickets to Vegas STAT.

Scorpio

You love to argue, which makes you terrifying. You will find a kindred spirit in your lawyer and decide to write a book together called *The Fine Art of Shutting It Down*.

Sagittarius

You love learning and are always on the hunt for additional knowledge. You will use this proclivity to unpack the intricacies of the tax code, and then unleash the awesome powers of the IRS on your ex's unsuspecting head.

Capricorn

You are disciplined and organized, which means you definitely own a color-coded binder full of Important Divorce Information. You will not-so-secretly enjoy putting together all the Ikea furniture you'll need for your new place.

Aquarius

You're a natural humanitarian. Fortunately, you also have the ability to suppress all those lovely instincts when it comes to securing your beloved book collection, which your ex believes should be "split equally." HELL TO THE NO.

Pisces

The pisces is represented by two fish swimming in opposite directions. Hooray for spot-on metaphors! You will pull a Stevie Nicks and go your own waaaaay (perhaps meeting some extremely hot other fishies on the journey).

GRATITUDE LIST

It's hard to feel upbeat when you're going through an event as life-changing—and usually sad, frustrating, and anxiety-inducing—as a divorce. But guess what? Science has shown over and over that gratitude is associated with improved physical, mental, and emotional health, and overall greater happiness.

So let's practice.

Today, I'm grateful for: _____

This person, who supported me when they didn't have to: _____

This person, who I had the opportunity to support: _____

This thing about my home: _____

This thing about my family: _____

This thing about my body: _____

This thing about my heart: _____

WORD SEARCH:
PROBLEMS THAT AREN'T YOURS ANYMORE

Congratulations! You no longer need to fight over the following:

LAUNDRY
DIRECTIONS
DISHWASHER LOADING
FEET ON THE TABLE
SOCKS ON THE FLOOR
EMPTY TOILET PAPER ROLL
IT'S TOO COLD
IT'S TOO HOT
WHICH TAKEOUT PLACE
WHICH TV SHOW
WHICH RADIO STATION
WHICH WAY
IS HAWAIIAN PIZZA GOOD*
WHO GETS TO PEE FIRST
WHO TAKES THE GARBAGE OUT
WHO TURNS OUT THE LIGHT
WHO LOST THE CHARGER
WHO LOST THE REMOTE
WHO THE DOG LIKES MORE

WHO'S MORE TIRED
HOW TO PRONOUNCE GIF
SUPER LOUD BREATHING
SUPER LOUD CHEWING
CAN THIS BE RECYCLED
WHAT "I'M" FINE ACTUALLY MEANS

*If your answer to this is "yes," you are wrong. Sorry.

portrait of person
who believed person
who said "I'm fine"

```
E N D A W D F M W Y D W N K D G K W F E L T J C P O W K Z C
W R I E Y H K E A H H L X U N A H D F O Y T A C L E H F D N
T G O Z L R O W E I I R O I W O I K N J U E W N B M O Q E Z
O V C M R C H T C T Z C W C L S N O I T C E R I D P G G V Y
H E F N S C Y H A F O E H O O P K W P C A T B X H T E C U L
O U S Y I E T C I K H N S R I O R L V Y M E K E E Y T W G I
O N M H U V K C E C E T T P A E T B O Q G L S N V T S H N F
T A W Z S P Z I D R T S Z H P D L S J Z F U A O M O T O I M
S R O H R P U U L H E C T R E B I D T D N S T W W I O S H N
T F O Y Q G O Y E G F B M H Z T E O O I U J O B J L P M T E
I W R T J L G C O L O K S Y E P A M S D L K O U A E E O A T
X L J C R U H N Y E L D L I Y G E B I T S B A D I T E R E O
T O Z E L A Q J O I N I E Z H J A S L T A V F L I P F E R M
A A P G R O L T I P X A V H K T H R R E B T G X D A I T B E
Y U M G G G F R U Q M V R F T A N F B P S N I H T P R I D R
S A E R A Z L F A F B V N J W O E A A A I G F O K E S R U E
B R G H M M G L Q I X G H A G S H I C D G U C T N R T E O H
W K Q E S V Q G I T D P I G L V M W A V C E Z U X R C D L T
J R F M P A M Y N S J I S C K D C O K O V W O V M O T E R T
W H A T I M F I N E A C T U A L L Y M E A N S U Q L X C E S
R U Q S V V M I I N G Q B E Z R U L A U N D R Y T L U Q P O
D E G L B J E R P T H G I L E H T T U O S N R U T O H W U L
O J O I N J L I K W H I C H T A K E O U T P L A C E L E S O
P M S F Z Y Z T X U D M S F I G E C N U O N O R P O T W O H
X J F G W Z W P R N R A S O C K S O N T H E F L O O R K Y W
R L N L A V C L L V W K S B U J O Q H M M D Y K S B W U D H
Y O E G M T E L O H E I X J A W F Y C V G L E Y W X U E F A
P T O T X O D C S R B N S U H M Z T D T Q I A P F R Z W Y W
K O Z X R M O I C P H R J C Y G Z F C T V C Q X P H M Z P X
D C D K A R D C X O X Y V J A L E H W F Z V N M O Y V B U W
```

131

DO SOMETHING NICE

Anger and resentment are toxic emotions: We know this. But it's also a fact that the best way to cure a shitty mood is by doing something nice for someone else. Don't worry, that "someone else" isn't your ex—let's keep our grip on reality here.
Try it; you'll see.

Call your mother. Ask her about her day. Listen.

Reach out to a former teacher. Tell them why they mattered so much.

Ask an elderly neighbor if there's anything they need help with, then help them.

Leave a bigger tip than you need to, if you can afford it.

Tell someone's boss what a great job they're doing.

Donate blood.

Take out your neighbor's trash.

Set up a monthly automatic donation to the charity of your choosing.

Let your kid off the hook.

Support your local bookstore. Thank them for what they do for your community.

When someone who helped you over the phone asks you to take the performance survey, do it. Give them a glowing review.

Foster an animal.

Pay a stranger a sincere compliment.

Do the household chore you know no one else wants to do.

Scrape the ice off of someone else's car.

Ask your cashier/taxi driver/hairdresser questions about their life. Listen.

Notice the name on a store clerk's name tag. Use it.

Let people merge in front of you in traffic. Smile to let them know it's okay.

Email someone you should have emailed a long time ago.

Let someone with fewer things to pay for check out ahead of you.

Let it—whatever "it" is—go.

A PEACEFUL AFTERNOON ALL TO YOURSELF

When you suddenly find yourself with that ever-elusive treasure called "solo time," it can sometimes be hard to remember: What do you even like to do when it's just you? An afternoon spent alone in the great outdoors might help you figure that out.

THINGS YOU MIGHT WANT TO BRING

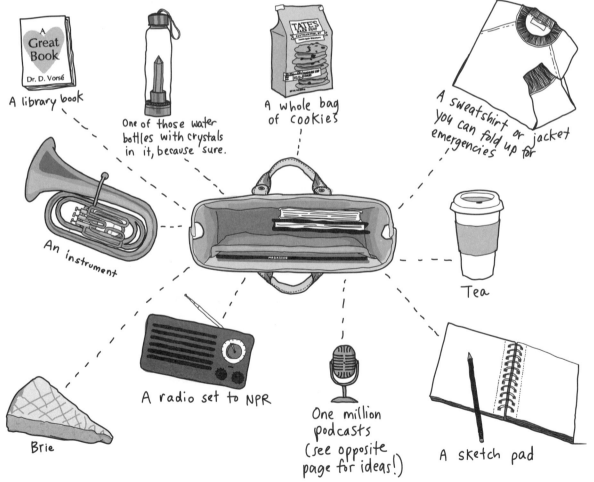

A library book

One of those water bottles with crystals in it, because sure.

A whole bag of cookies

A sweatshirt or jacket you can fold up for emergencies

An instrument

Tea

Brie

A radio set to NPR

One million podcasts (see opposite page for ideas!)

A sketch pad

SPEAKING OF PODCASTS...

Whether you're looking for commiseration, information, entertainment, or a fully novocained brain, there is a podcast for you.

LEARNING ABOUT A THING

The Dream: Essential listening for anyone fascinated by the cultish world of multi-level marketing

99% Invisible: The stories of all the little things we don't think about

Revisionist History: Malcolm Gladwell takes a second look at the past

Code Switch: From NPR, fearless and inclusive conversations about race

BRAIN-OFF MODE

Even the Rich: Irresistible gossip about the world's richest families

The Baron of Botox: The sad but fascinating story of Dr. Brandt, a Botox pioneer who became addicted to his product

Lore: A modern take on scary campfire stories, with episodes covering everything from vampires to iconic haunted houses

TRUE CRIME JUNKIES, REJOICE

Dateline: The classic TV show translated for the podcast audience with loads of content to explore (listen to too many in a row and you're bound to start triple-checking the locks at night)

Detective Trapp: Badass lady cop hunts serial killer. Are you in?

Someone Knows Something: True crime stories from our neighbors to the north

The Fall Line: Unsolved murders that have received little or no public attention, particularly cases involving marginalized communities in the Southeast

Criminal: A surprising and critical look at the world of true crime

In the Dark: Season two's story of Curtis Flowers, a man tried six times for the same crime, is not to be missed

Finding Cleo: Part story of a young, indigenous woman who goes missing in Canada, part cultural and historical reckoning

QUIZ:

ARE YOU GOING TO BE OKAY?

It's something we all wonder from time to time. Find out once and for all whether you're going to pull through this crazy moment in your life.

1. What does your house look like right now?
 a) Um, like it always does?
 b) Sparkling like a $10,000 per night spa, exactly like I always wanted
 c) We're taking it easy on ourselves, okay?
 d) Trashed, because fuck it

2. How many hours per night do you sleep?
 a) Precisely eight, because routine is important
 b) Twelve to sixteen, because beauty rest is important
 c) Four to six, because Netflix is important
 d) I retire at pinot noir o'clock and wake up at the crack of espresso

3. How's your diet?
 a) I eat three carefully balanced meals per day so as to keep up my energy levels
 b) I enjoy a steady stream of pasta, full-fat cheese products, and Yodels
 c) Unclear, but I appear to still be alive, so: yay
 d) Do cigarettes count as a food group?

4. What do you wear on the average day?
 a) Um, clothing?
 b) Carefully curated ensembles, including sexy underwear
 c) A fleece sweatsuit that feels like a hug
 d) Whatever doesn't smell (too much)

5. How's your work going?
 a) Fine—my colleagues know I'm going through a tough time, but I'm not letting it affect my output
 b) Great! I've never felt more creative!
 c) My productivity is down, but I'll bounce back
 d) I quit three weeks ago and am living off unemployment checks and cake

6. What's your social life like?
 a) I've been making an effort to go out and see friends a couple of times a week, per usual
 b) All the dates and all the parties and all the single everythings, and it is glorious
 c) 90 percent of my interactions are with my lawyer and/or my therapist; the remainder are Postmates deliveries
 d) If "turning my phone on airplane mode, then lying flat on my back on the floor and crying" counts as "having a social life," I'm killing it

Mostly As: Congratulations! You are going to be okay.
Mostly Bs: Congratulations! You are going to be okay.
Mostly Cs: Congratulations! You are going to be okay.
Mostly Ds: Congratulations! You are going to be okay.

GUESS WHAT?

A FEW WISE WORDS FROM A FEW WISE PEOPLE

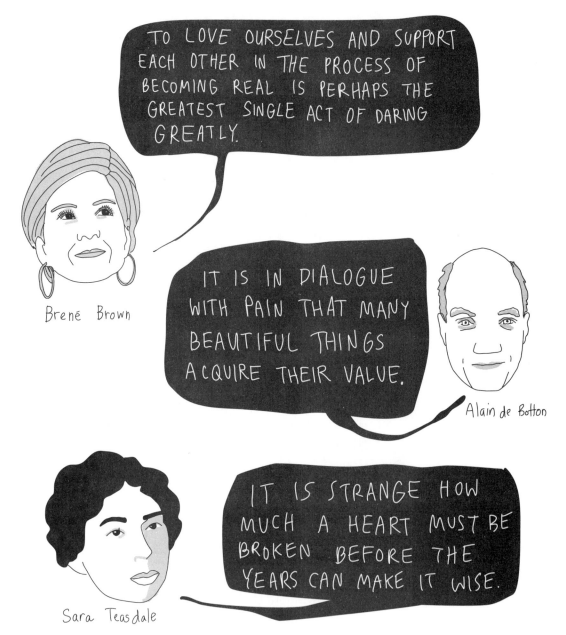

TO LOVE OURSELVES AND SUPPORT EACH OTHER IN THE PROCESS OF BECOMING REAL IS PERHAPS THE GREATEST SINGLE ACT OF DARING GREATLY.

Brené Brown

IT IS IN DIALOGUE WITH PAIN THAT MANY BEAUTIFUL THINGS ACQUIRE THEIR VALUE.

Alain de Botton

IT IS STRANGE HOW MUCH A HEART MUST BE BROKEN BEFORE THE YEARS CAN MAKE IT WISE.

Sara Teasdale

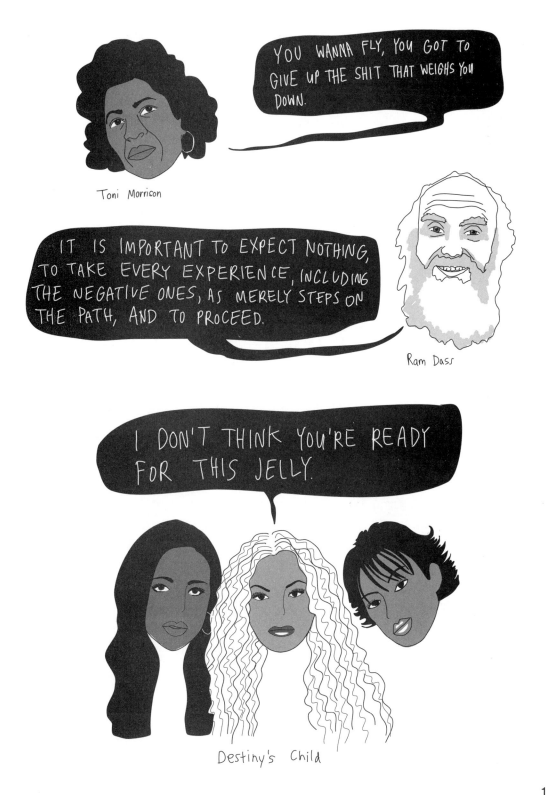

LET IT OUT.

LET IT OUT.

LET IT OUT.

LET IT OUT.

LET IT OUT.

LET IT OUT.

Also by
JORDAN REID and ERIN WILLIAMS